YOSEMITE & THE WILD SIERRA

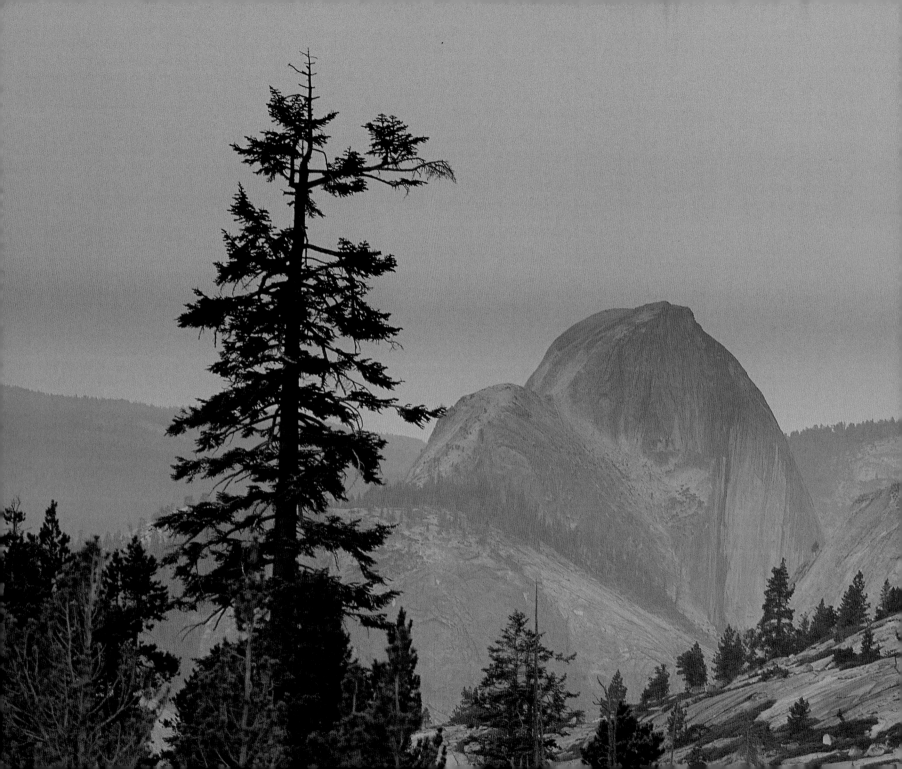

YOSEMITE & THE WILD SIERRA

photographs and foreword by GALEN ROWELL

edited by JENNIFER BARRY

SASQUATCH BOOKS
SEATTLE

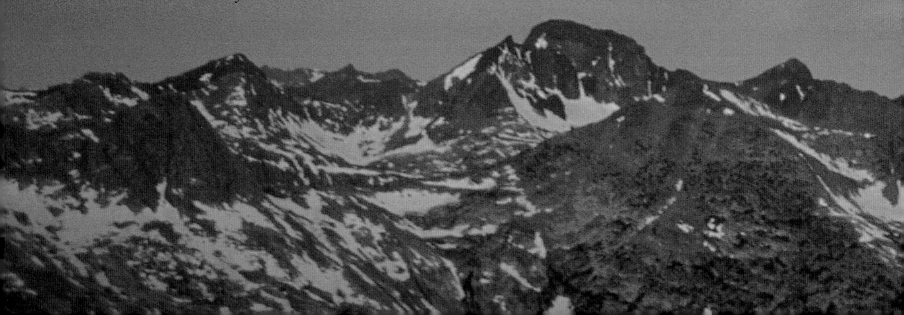

Editor's Dedication to Galen Rowell, 1940–2002

I've only come to look back down
On the valley orchards and vineyards,
And to mourn my friend, another son
Of that valley and these burned hills,
Hills that rolled through his first
Memories and stayed,
No matter what cities he found himself in,
No matter what hotel he checked out of,
The one geography of his life.
So many times he seemed to me

A solitary, peering down
From an oak older than both
Our ages combined, a century tree,
But as a man of place
Placed among men of property,
I'm sure the last landscape he drew
Was bordered by these hills,
Oak by oak, rock by rock,
All the way past timberline.

C.G. HANZLICEK

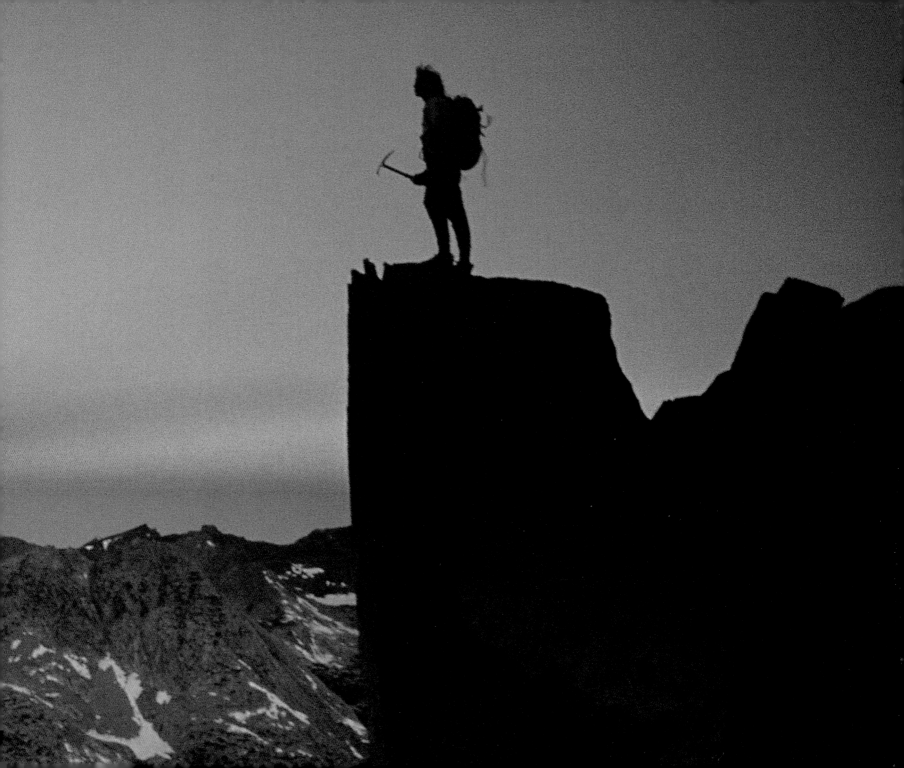

FOREWORD

Not a single road crosses the wild crest of the Sierra Nevada for two hundred miles south of Yosemite.

This special region at the southern end of the range where the mountains rise high above timberline into eternal snows earned the name "High Sierra" more than a century ago. In 1915 a trail was begun to follow near the crest of the range, beginning beneath the grand walls and waterfalls of Yosemite Valley and ending 211 miles later atop 14,495-foot Mount Whitney, the highest peak in the contiguous forty-eight states.

Named the John Muir Trail after the great nineteenth-century naturalist who helped found both the Sierra Club and Yosemite National Park, the route traverses a region Muir called "the gentle wilderness." What separates the High Sierra from other ranges of the world with spectacular mountain scenery is its unusually fine weather and relatively easy access. The areas covered in this book are mostly within the largest area of contiguous designated wilderness in America, outside Alaska. They include three national parks, one national monument, and several national forest wilderness areas.

Near timberline, cross-country travel becomes sheer delight. Even below timberline, open stands of Jeffrey, lodgepole, and whitebark pines are never so thick that a person can't find an easy

pathway where it appears no human has gone before. Sierra Club backcountry pack trips came up with the motto, "Life begins at 10,000 feet." Though arriving at this magical altitude where the trees begin to thin, the views expand, and the lakes and streams abound often requires hours of hiking from a distant valley below, a few such places are accessible by paved roads. One has only to climb fifty-nine feet above the Tioga Pass entrance to Yosemite National Park to reach 10,000 feet. Exquisite Little Lakes Valley in the Eastern Sierra has pavement right up to 10,200 feet at the edge of the John Muir Wilderness.

When I hiked into the High Sierra backcountry with my family as a teenager in the 1950s, I loved the sight of clean alpine meadows, well above timberline, dotted with flowers and boulders, but I failed to make the connection that, regardless of the California summer beneath my feet, I was standing in the Arctic life zone of my planet. The Sierra Club's 10,000-foot mark in California coincides with a well-defined polar boundary. This life zone just below timberline is called "Hudsonian," because its climate and vegetation match those of the region beside Hudson Bay in northern Canada. The next higher zone is called "Arctic/Alpine" because a similar climate is found both at high latitudes in the Arctic and high altitudes in the Alps.

Yosemite Valley may be only at 4,000 feet, but it wouldn't exist if it wasn't for the influence of terrain well above 10,000 feet near the crest of the High Sierra. The valley was carved out to its present shape by the merging of five great glaciers born on the snowy heights of the range.

On the other side of the range, just east of the crest, the tremendous appeal of the high desert of the Owens Valley at 4,000 feet is due to the influence of the huge Sierra escarpment, always in view overhead. Nestled between 14,000-foot mountains on either side, this valley is America's deepest, with scores of snow-fed streams pouring down its flowered flanks toward the sagebrush plains below.

Mono Lake, made famous by the battle to save it from losing its water to thirsty Los Angeles, still fits Mark Twain's description of "a solemn, silent, sailless sea." But this alkaline lake, set in a separate high-desert basin with no outlet, also owes its existence to the melting snows of the High Sierra. During the Ice Ages, a great glacier extended all the way from what is now Yosemite National Park down Lee Vining Canyon into the lake itself, where icebergs calved off and floated in a scene much like that of Alaska's Glacier Bay today.

Though I have visited many ranges that are higher and found isolated clusters of peaks that are more spectacular, I have yet to discover a place with the incredible diversity of beauty and landforms and light that I regularly experience in the High Sierra. I constantly find myself saying, this valley is just like Alaska, that peak is just like Nepal, this arid landscape capped with snow is just like

the Karakoram. Only in Yosemite Valley do I refrain from mental comparisons. There is only one Yosemite on the face of the Earth.

John Muir called the High Sierra "The Range of Light." Though he was not a photographer, he recognized the way the white granite and snows reflected the glow of eternal sunrises and sunsets. I taught myself how to pursue magical light like clues on a treasure map, and I like to say that the High Sierra was my teacher. I never simply lift my camera up and shoot. I only photograph what I'm passionate about. When I have the urge to take a picture, I stop and ask myself, "What is it that makes me want to take a photograph here?" It's almost never the whole scene, only the special way that certain parts of it come together in my mind. What I try to do is compose them in much the same way for someone who wasn't there to experience it firsthand. I learned long ago that it's not objects themselves that we respond to, but the way they have been assembled in a photograph for us to interpret through the mind and eye of another human being.

It is my hope that the images and quotations in this book come together in each reader's mind to form powerful images of the enduring wildness and incomparable beauty that extends from Yosemite southward along the High Sierra. Whether or not readers ever visit these places and witness similar natural moments themselves, just knowing that this wildness exists and is protected by law is part of what makes our nation free. These lands belong to all the American people. Anyone who makes the effort can visit them and enjoy them in person or in photographs.

—Galen Rowell, Bishop, California, November 2001

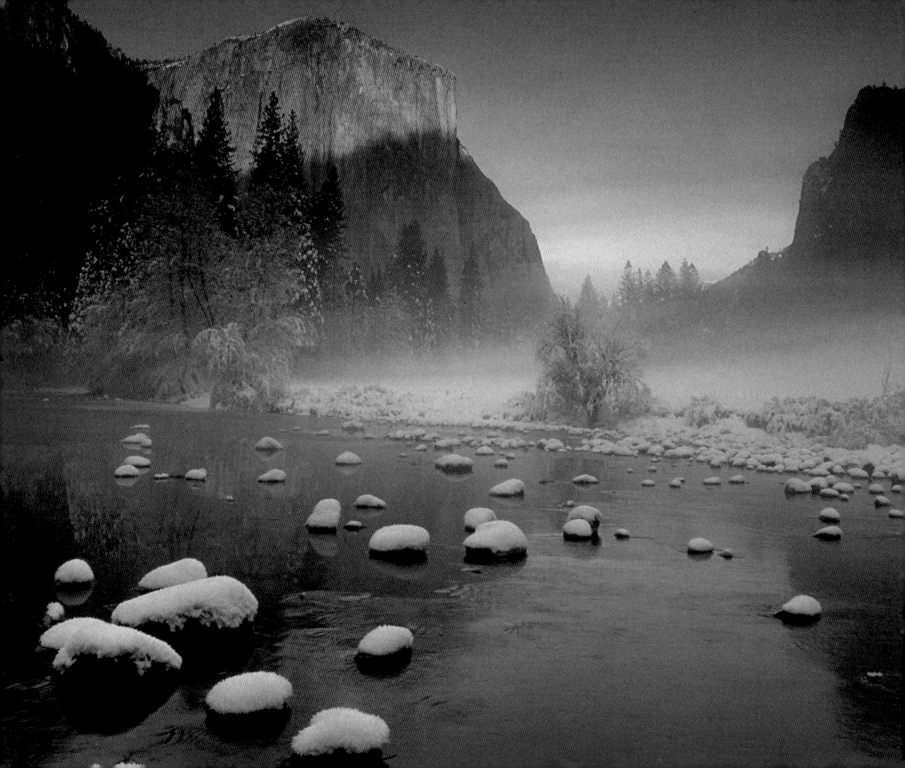

. . . beyond this masquerade

Of shape and color, light and shade,

And dawn and set, and wax and wane,

Eternal verities remain.

Gates of the Yosemite Valley in winter

The last days of this glacial winter are not yet passed, so young is our world. I used to envy the father of our race, dwelling as he did in contact with the new made fields and plants of Eden; but I do so no more, because I have discovered that I also live in "creation's dawn." The morning stars still sing together, and the world, not yet half made, becomes more beautiful every day.

JOHN MUIR

Twilight mist over the Merced River,
Yosemite Valley

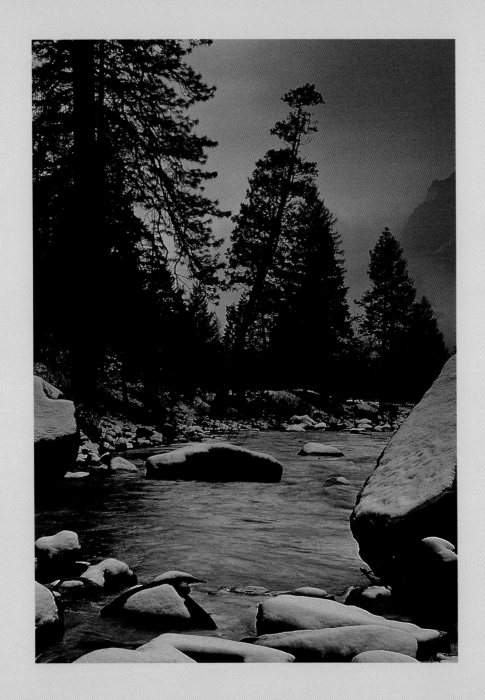

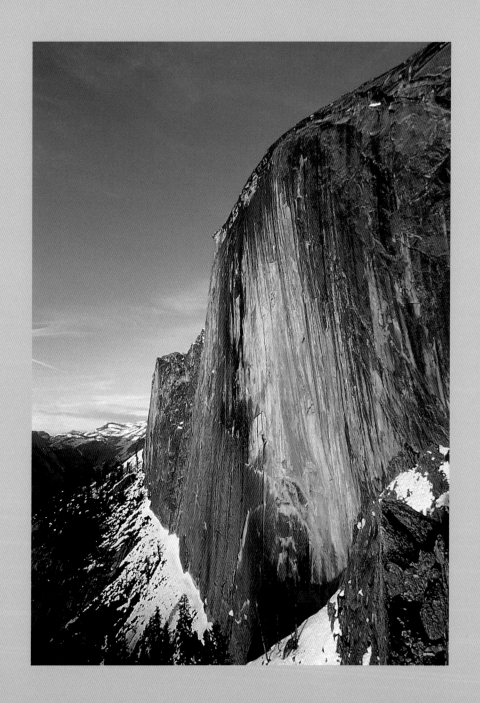

Such magnificence of rocks, such stupendousness of cliffs, far outstripped conception, and staggered even perception itself. You disbelieve your own eyes. Judgment fails you. You have to reconstruct it. Comparison serves you little, for you have no adequate standard with which to compare, or by which to estimate the rock-mountains before you. They are like nothing else but themselves.

SAMUEL KNEELAND

Northwest face of Half Dome

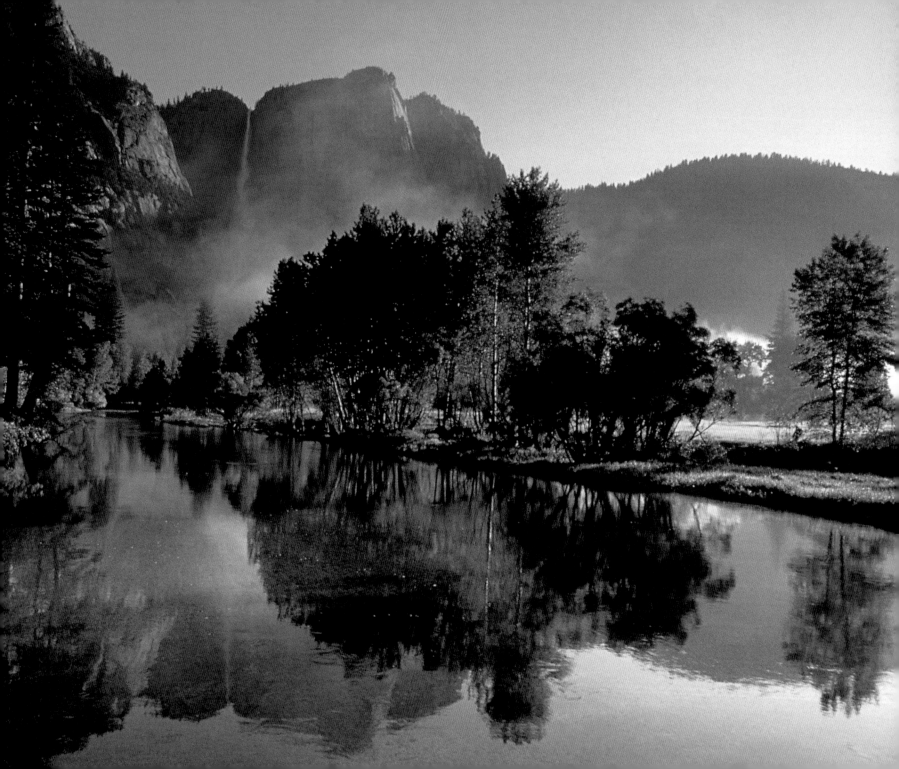

The view which here burst upon us, of the valley and the Sierra, it is simply impossible to describe. . . . To the left stands El Capitan's massive perpendicular wall; directly in front, and distant about one mile, Yosemite Falls, like a gauzy veil, rippling and waving with a slow, mazy motion; to the right the mighty granite mass of Half Dome lifts itself in solitary grandeur, defying the efforts of the climber . . .

JOSEPH LECONTE

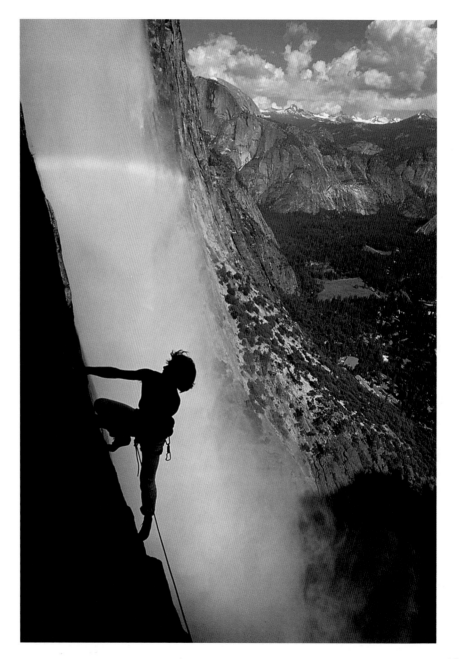

The Merced River in spring flood,
Yosemite Valley *(left),* rainbow in spray
of Upper Yosemite Fall *(right)*

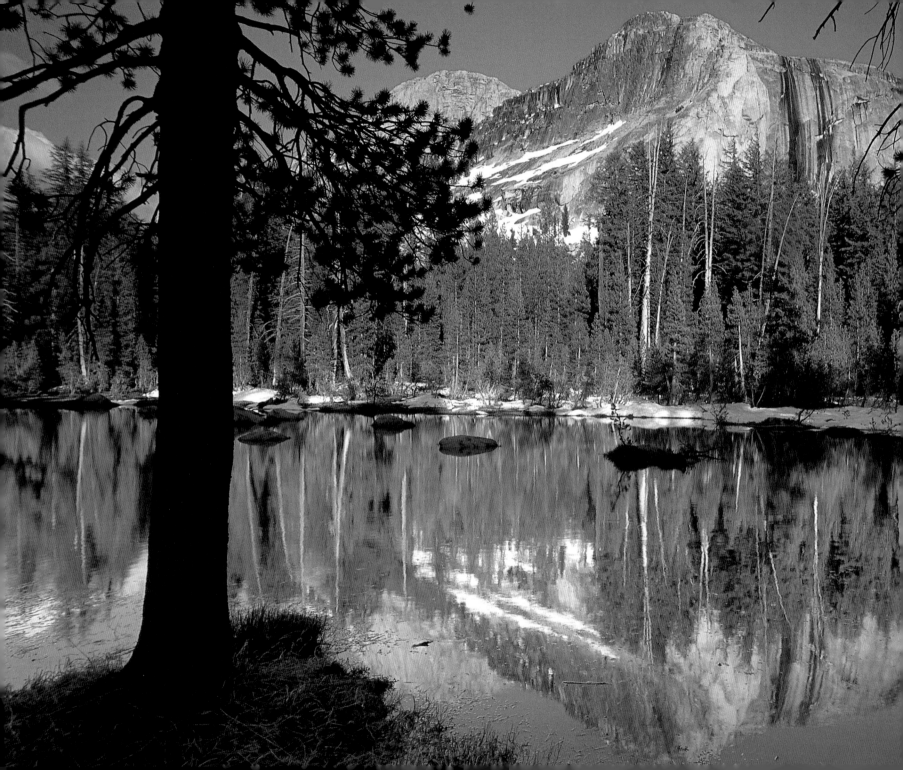

Gray and bleakly majestic,

 the bastioned walls of the valley,

 Springing sheer to the sky,

 dwarf the great pine trees beneath.

CHARLES WHARTON STORK

Domes in the Yosemite high country near
Tuolumne Meadows

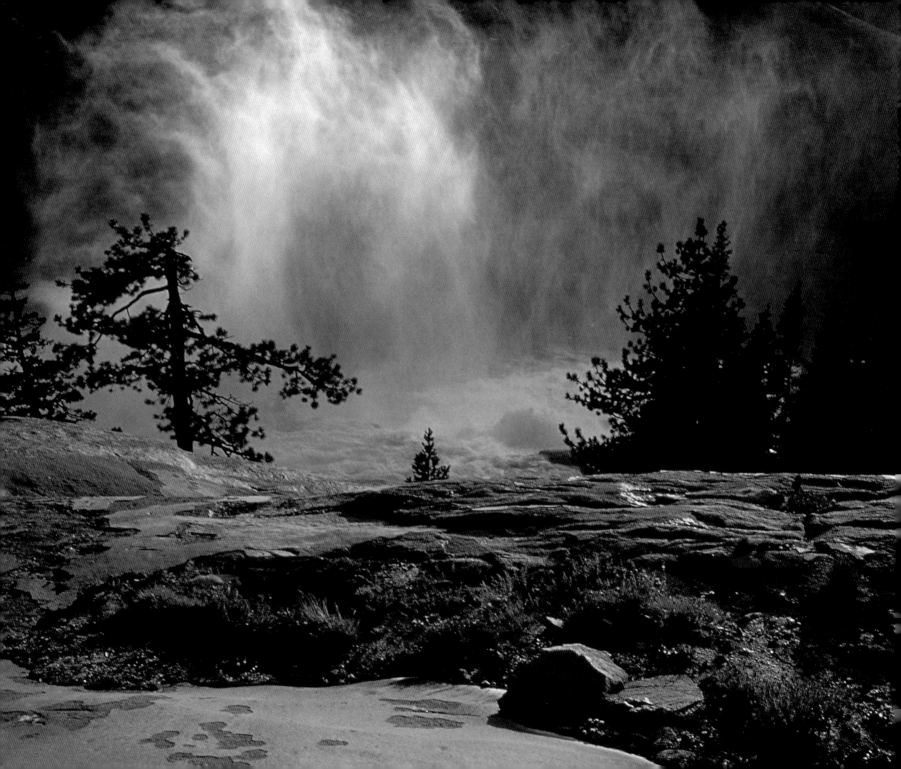

Now comes the great drama of the Sierra. The streams gather volume and begin a boisterous journey, plunging to the depths of canyons in leaping and twisting cascades. In Yosemite, heart of the Sierra, the forms of water attain their most exciting expression. There the great waterfalls leap from lofty cliffs in magnificent variety. . . . Whether in motion or at rest, the waters of the Sierra are a constant joy to the beholder. Above all, they are the Sierra's greatest contribution to human welfare.

FRANCIS P. FARQUHAR

Wildflowers and mist below Waterwheel Falls,
Grand Canyon of the Tuolumne River *(left)*, and
rainbow over Waterwheel Falls *(right)*

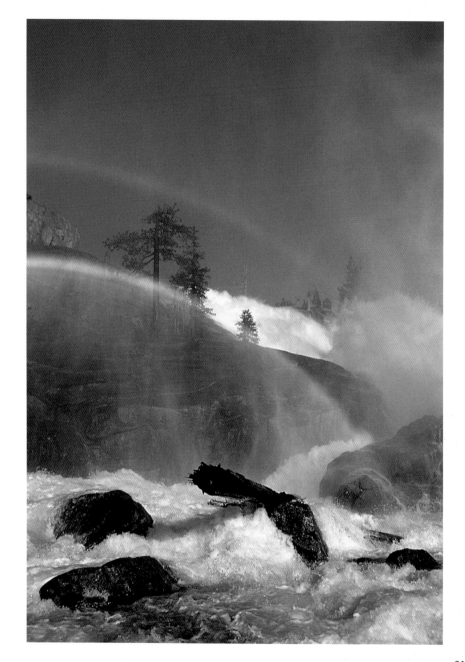

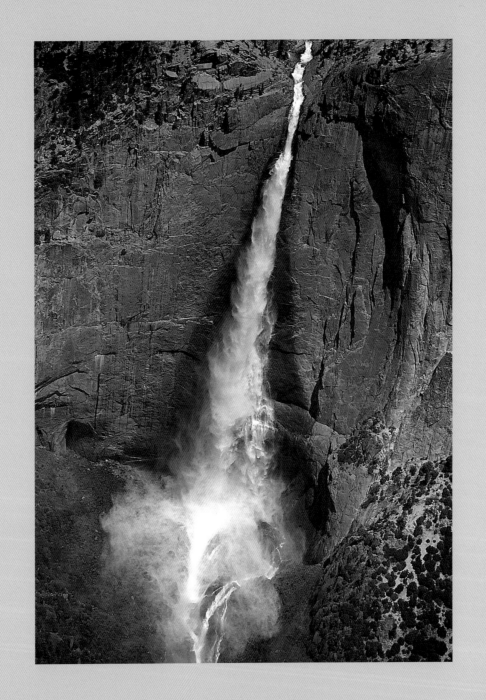

Hung on the eaves of the world, the thin ribbon dangles and flutters;

Broadly the Vernal spreads its mantel of feathery spray;

Headlong Yosemite leaps, and pauses, and leaps again forward;

Cliff-overshadowed Nevada gleams from the dark like a wraith.

CHARLES WHARTON STORK

Upper Yosemite Fall from the air,
Yosemite National Park

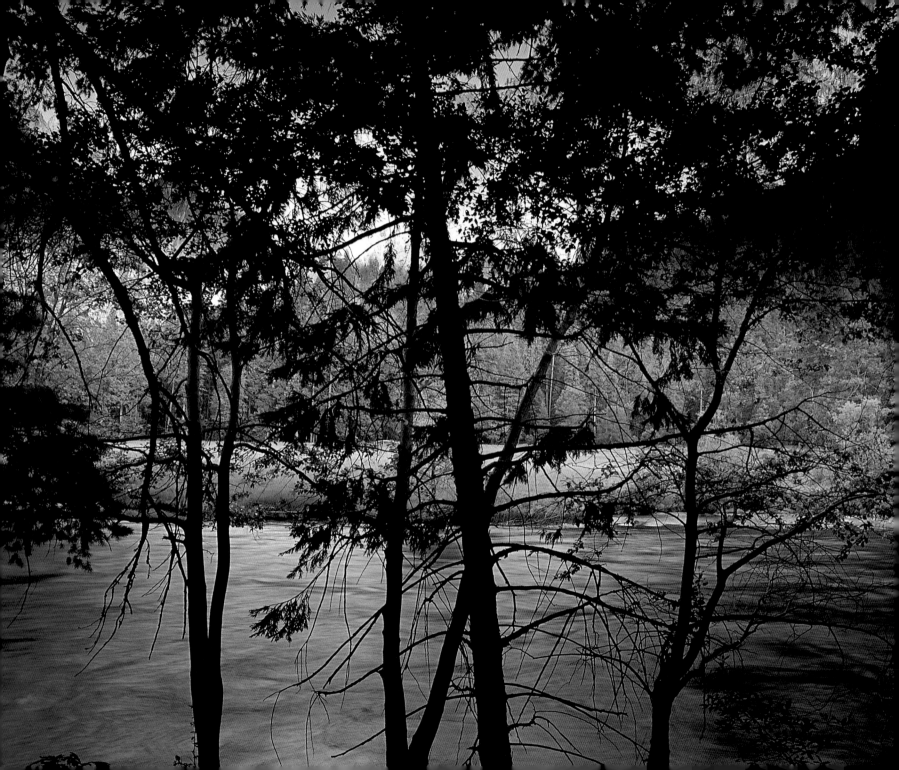

The trees are never the same

 twice

 the animals

 the birds or

The little river lying on its back in the sun or the sun or
The varying moon changing over the changing hills
Constant.

 It is this, still, that most I love about them.

I enter by dark or day:

 that green noise, dying
Alive and living its death, that inhuman circular singing,
May call me stranger . . .

 Or the little doors of the bark open
And I enter that other home outside the tent of my skin . . .

On such days, on such midnights, I have gone, I will go,
Past the human, past the animal, past the bird,
To the old mothers who stand with their feet in the loamy dark
And their green and gold praises playing into the sun . . .

For a little while, only. (It is a long way back.)
But at least, and if but for a moment, I have almost entered the stone.
Then fear and love call. I am cast out. Alien,
On the bridge of fur and of feather I go back to the world I have known.

THOMAS MCGRATH

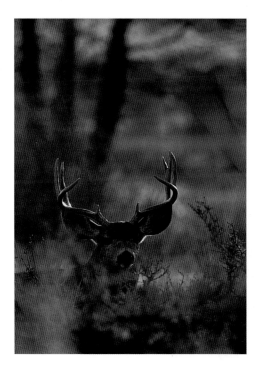

Merced River, Yosemite Valley *(left),*
and a mule deer *(right)*

Every day opens and closes like a flower, noiseless,

effortless. Divine peace glows on all the majestic

landscape like the silent enthusiastic joy that

sometimes transfigures a noble human face.

JOHN MUIR

Owls clover at sunset, Tuolumne Meadows

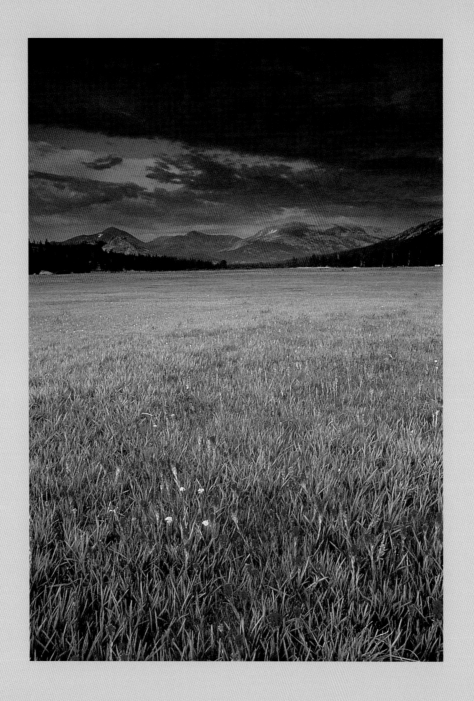

Nothing could be more agreeable to us
than the sight and the shade of these
stately giants of the forest, piercing the sky
with their tall and arrow-straight forms.

EDWIN BRYANT

Moonset from Olmsted Point,
Yosemite National Park

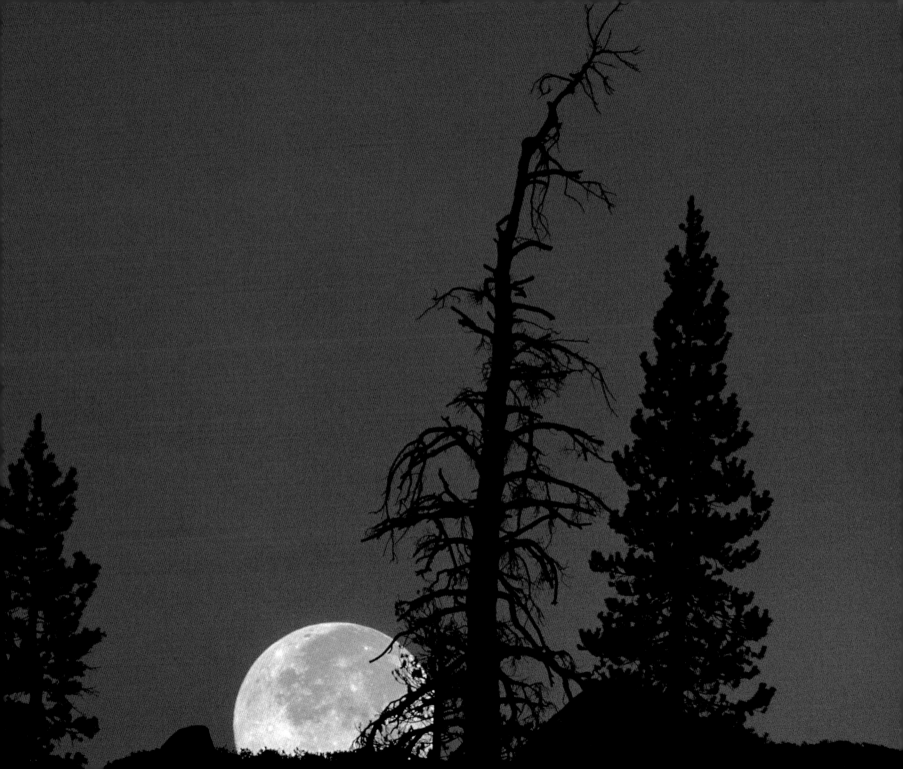

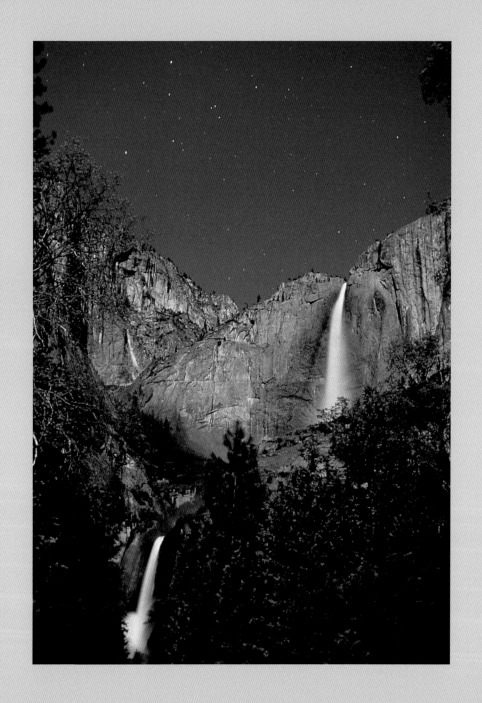

If, when a blind moth

eclipses the moon

outside of time

you can't see wishes

re-lit from the tail ends

of old wishes—

look up from a bed

of eyeless needles

to the owl's cry

vaporized

into a streak

of light, a spark

stirred from the hot bed

of smoky stars

little deaths

you must be ready for

with all your eyes.

DIXIE SALAZAR

Yosemite Falls by moonlight *(left)*, and
an immature great horned owl *(right)*

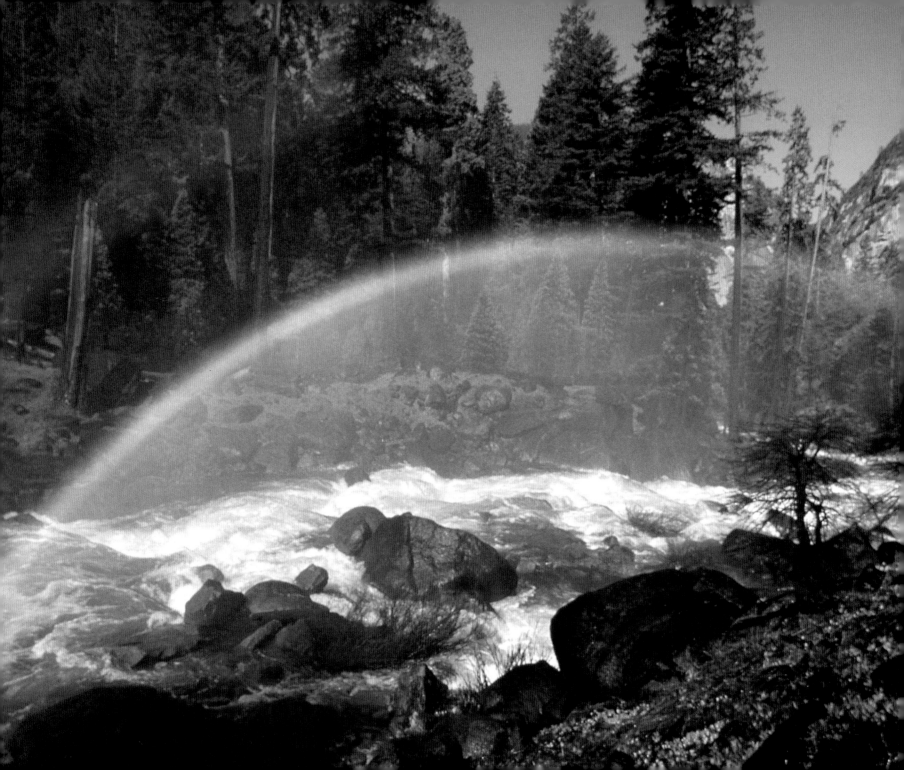

. . . it was pure delight to be where the land lifted in peaks and plunged in canyons, and to sniff air thin, spray-cooled, full of pine and spruce smells, and to be so close-seeming to the improbable indigo sky. I gave my heart to the mountains the minute I stood beside this river with its spray in my face and watched it thunder into foam, smooth to green glass over sunken rocks, shatter to foam again.

WALLACE STEGNER

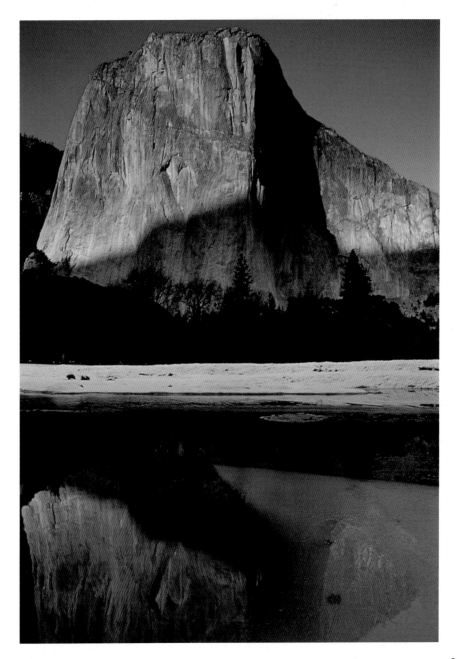

Rainbow over the Merced River *(left),* and
El Capitan reflected in the Merced River *(right)*

33

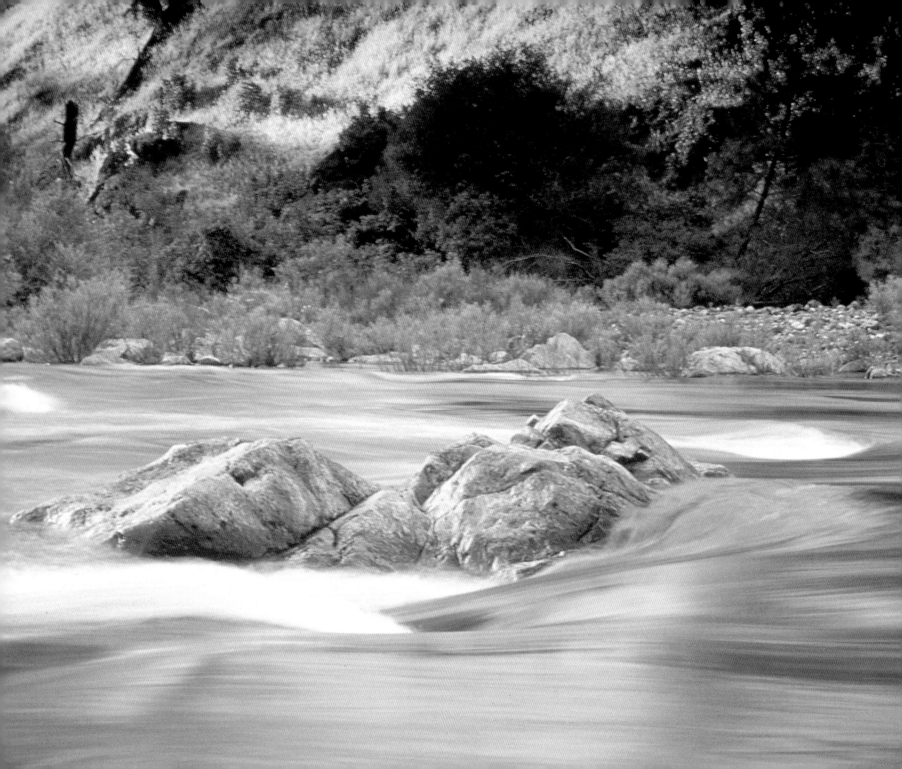

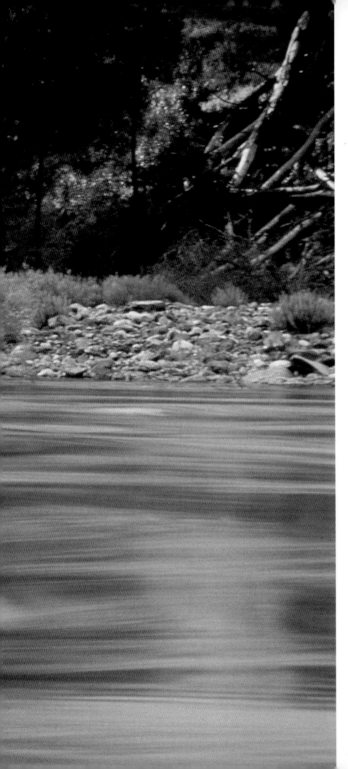

By such a river it is impossible to believe that one
will ever be tired or old. Every sense applauds it.
Taste it, feel its chill on the teeth: it is purity absolute.
Water, its racing current, its steady renewal of force:
it is transient and eternal.

WALLACE STEGNER

Tuolumne River above Clavey Falls

I suspect the real glories of Yosemite belong to the
backpackers, the trudgers and trekkers, those who
finish a strenuous climb and wait for their psyches to
catch up, suffer a thunderstorm on an alpine fell, and
most of all, let the night spirits seep into their sleep.
The real glories of Yosemite belong to those who are
comfortable with being uncomfortable, who know
it's all right to be afraid, to be cold, wet, tired, and
hungry, to be euphoric and, on occasion, ecstatic.

ANN ZWINGER

Descending the Mist Trail into Yosemite Valley

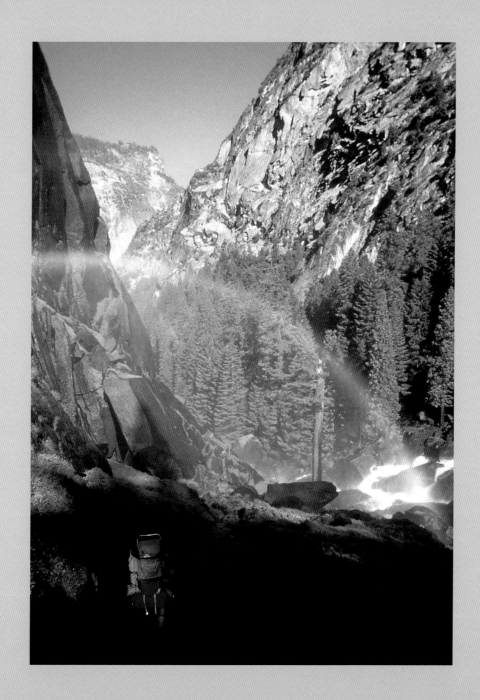

Wander here a whole summer, if you can.

Thousands of God's wild blessings will search

you and soak you as if you were a sponge,

and the big days will go by uncounted.

JOHN MUIR

Sunrise on Tioga Pass

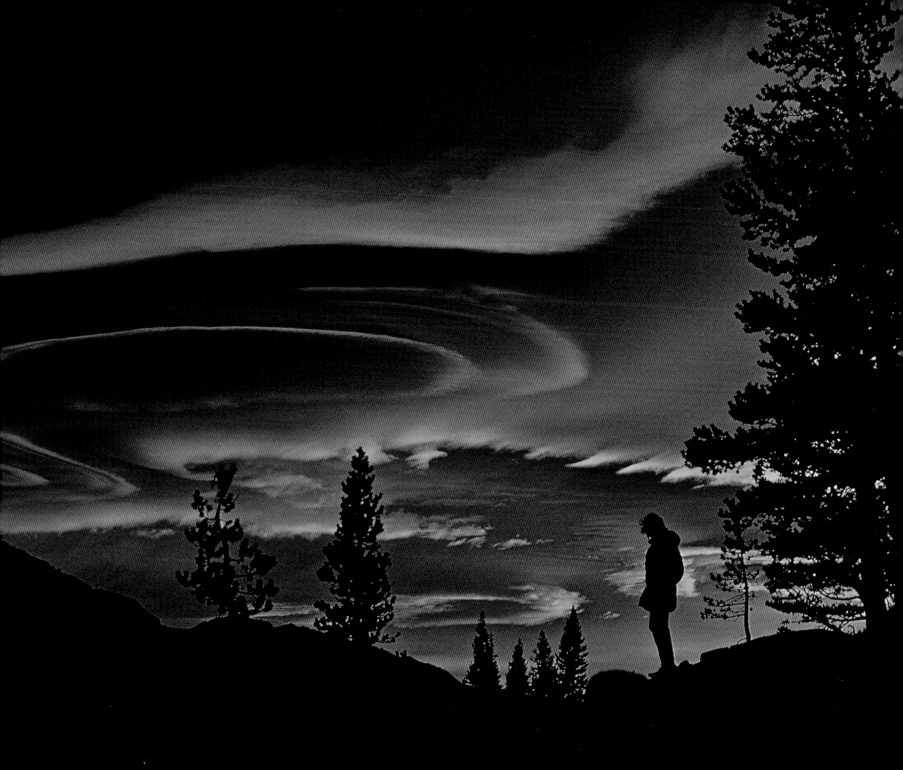

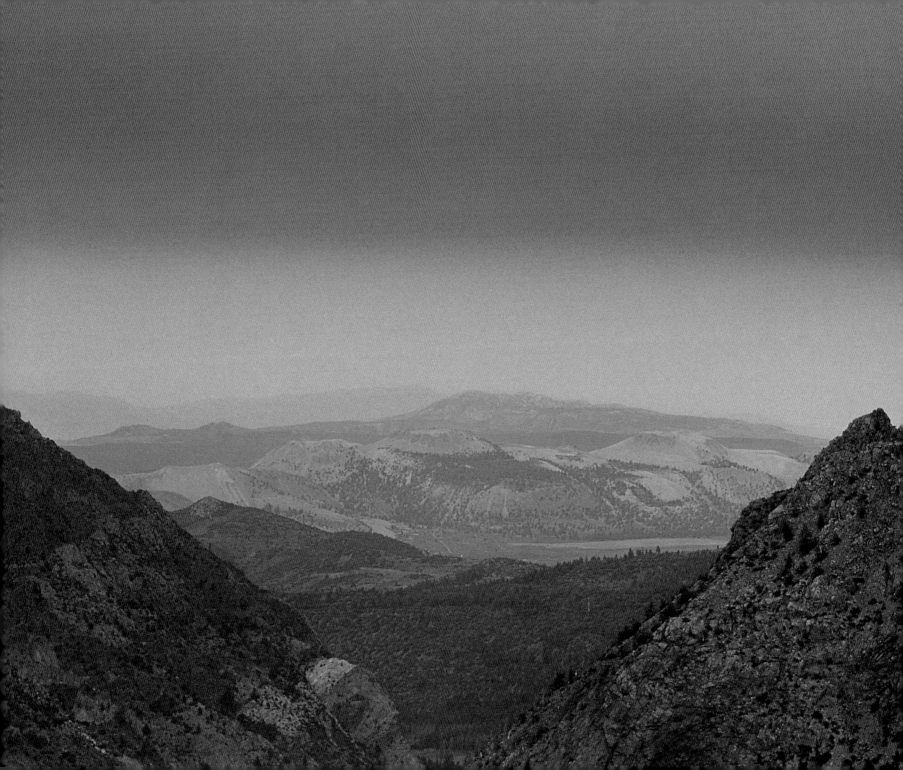

Opposite the mouth of the cañon a range of
volcanic cones extends southward from the lake, rising
abruptly out of the desert like a chain of mountains. . . .
At a distance of a few miles they look like heaps of
loose ashes that have never been blessed by either rain
or snow. . . . A country of wonderful contrasts.

JOHN MUIR

Earth shadow over Mono Craters
from Lee Vining Canyon

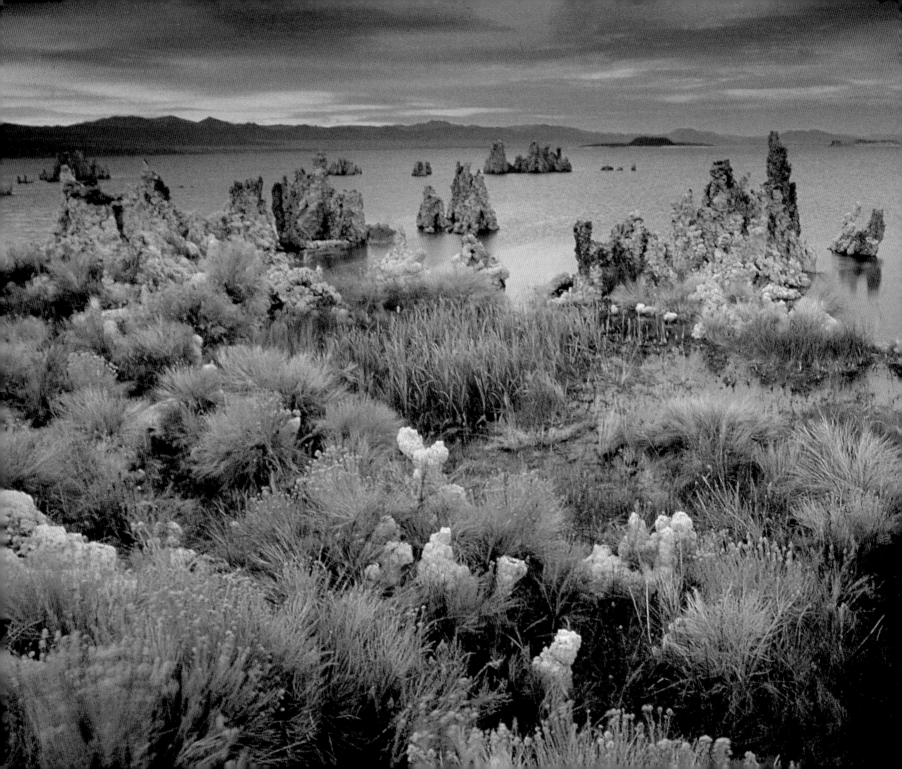

Mono Lake lies in a lifeless, treeless, hideous desert, eight thousand feet above the level of the sea, and is guarded by mountains two thousand feet higher, whose summits are always clothed in clouds. This solemn, silent, sailless sea—this lonely tenant of the loneliest spot on earth—is little graced with the picturesque. It is an unpretending expanse of grayish water, about a hundred miles in circumference, with two islands in its center, mere upheavals of rent and scorched and blistered lava, snowed over with gray banks and drifts of pumice-stone and ashes, the winding-sheet of the dead volcano, whose vast crater the lake has seized upon and occupied.

MARK TWAIN

Stormy fall sunset over Mono Lake

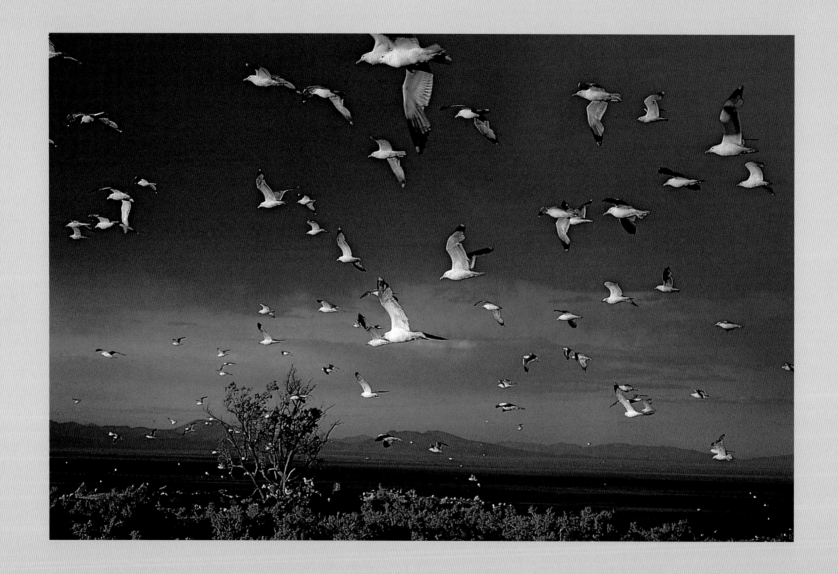

Tourists who watch these gulls scavenge tidbits

at San Francisco's Fisherman's Wharf are usually

unaware that they live inland for much of the year.

During Pleistocene times, the California gulls

populated inland seas that filled much of the Great

Basin. Their descendants continue to return to the

last remnants of their ancestral birthplace to nest.

. . . Negit Island in Mono Lake became the world's

largest nesting colony for California gulls.

GALEN ROWELL

California gulls on Negit Island, Mono Lake

Most of all, I was awed, very early and indelibly. . . .

The universe was neither hostile nor friendly, simply indifferent

to my small, freezing-handed, steam-breathing figure in the

white waste. You do not feel that mystery in city canyons or on

suburban lawns. What you feel is the specious persuasiveness

of human control, human management and organization and

rearrangement. You do not know who the ultimate Authority is.

Out in the public lands, where the nearest neighbor may be

ten miles away and the stars are closer than the nearest town,

you do.

WALLACE STEGNER

Moonrise over the Sherwin Plateau, Eastern Sierra

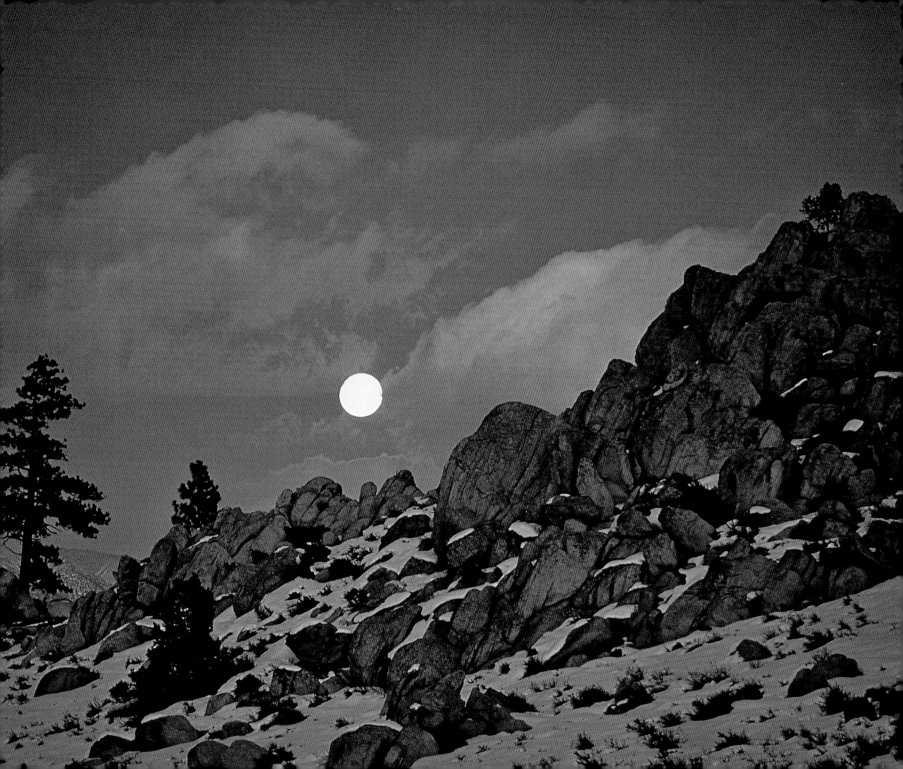

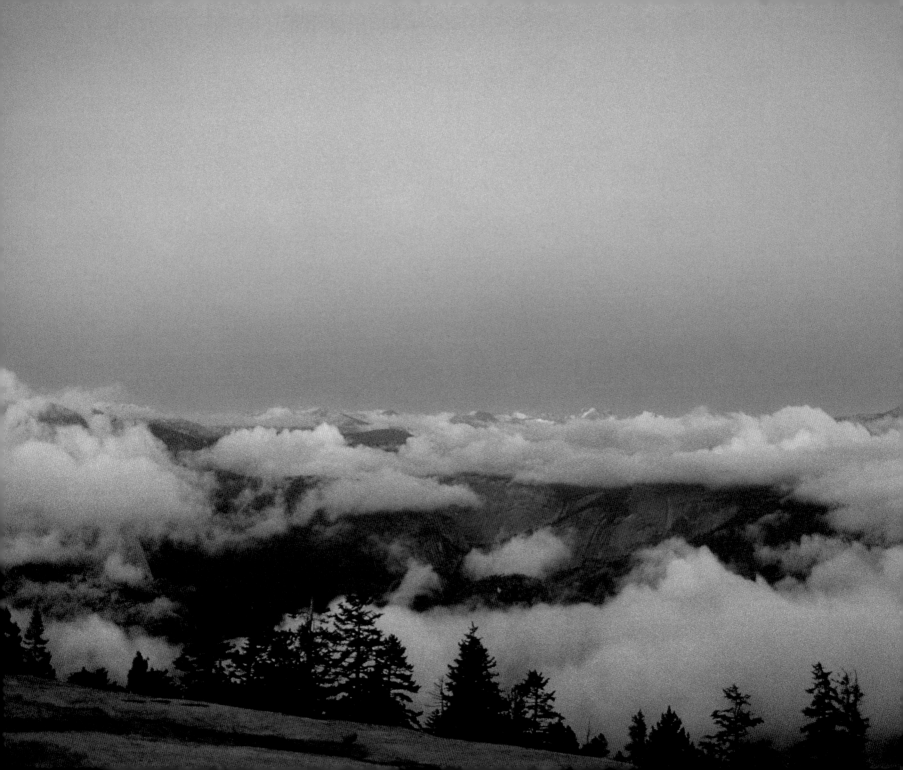

On the last day of the world
I would want to plant a tree

what for
not for the fruit

the tree that bears the fruit
is not the one that was planted

I want the tree that stands
in the earth for the first time

with the sun already
going down

and the water
touching its roots

in the earth full of the dead
and the clouds passing

one by one
over its leaves

W. S. MERWIN

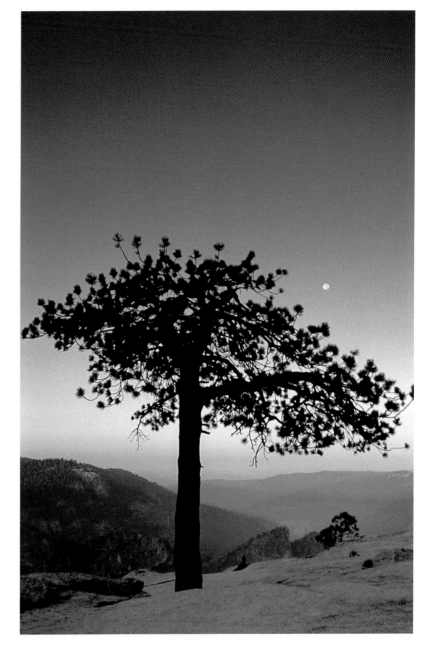

Twilight over the Clark Range *(left)*, and moon and
Jeffrey pine on Taft Point above Yosemite Valley *(right)*

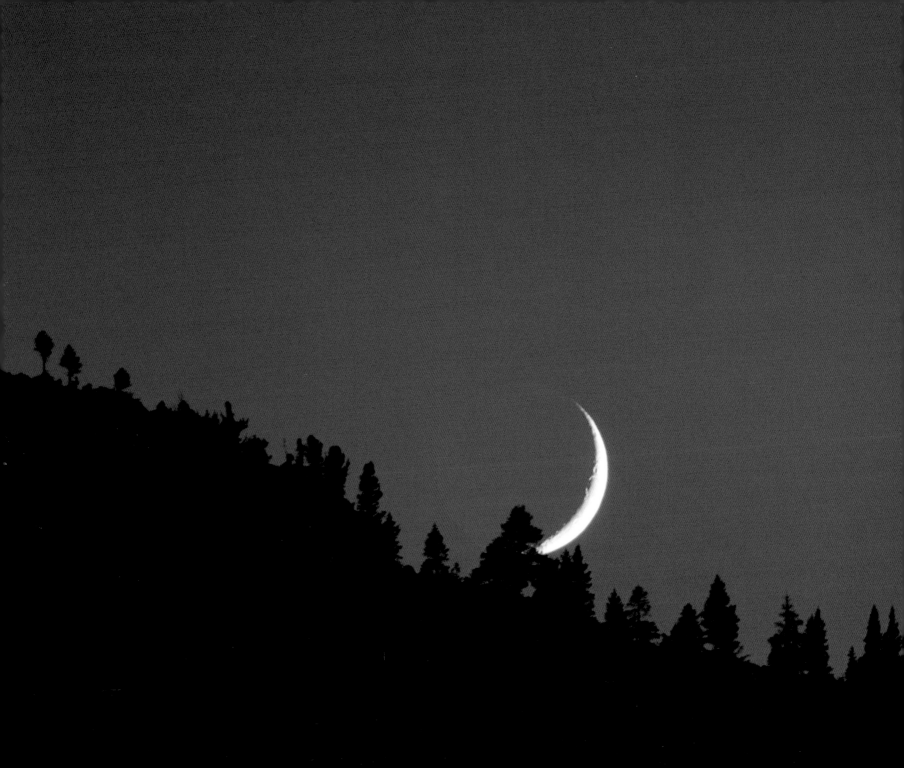

Only by going alone in silence, without baggage, can one truly get into the heart of the wilderness. All other travel is mere dust and hotels and baggage and chatter.

JOHN MUIR

Crescent moon over Squaw Lake,
John Muir Wilderness *(left)*, and moonrise in the
Ansel Adams Wilderness *(following pages)*

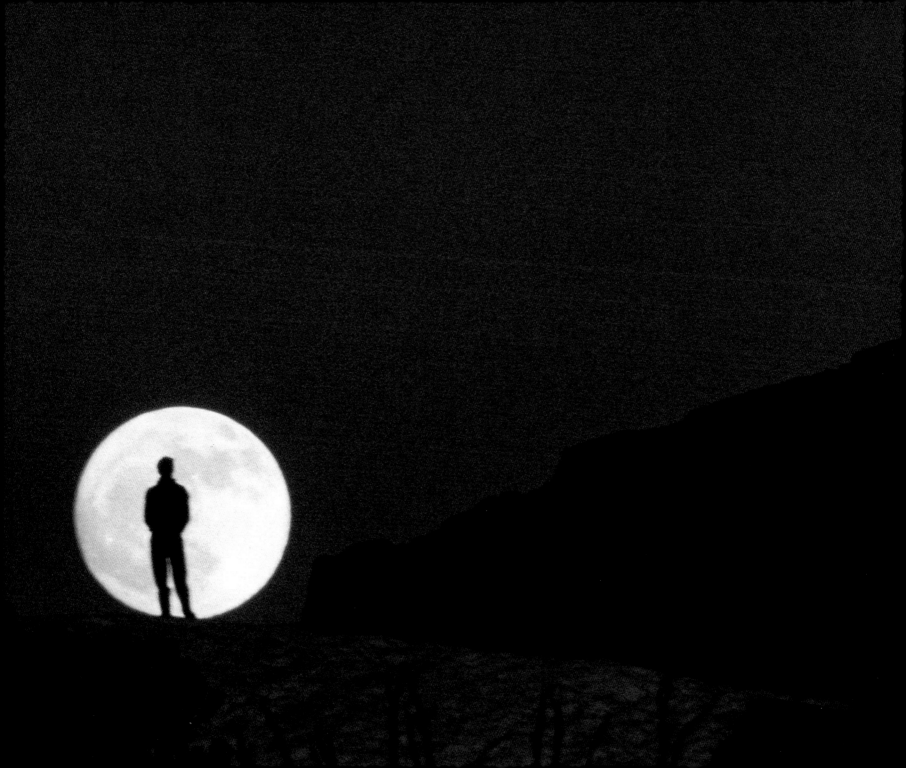

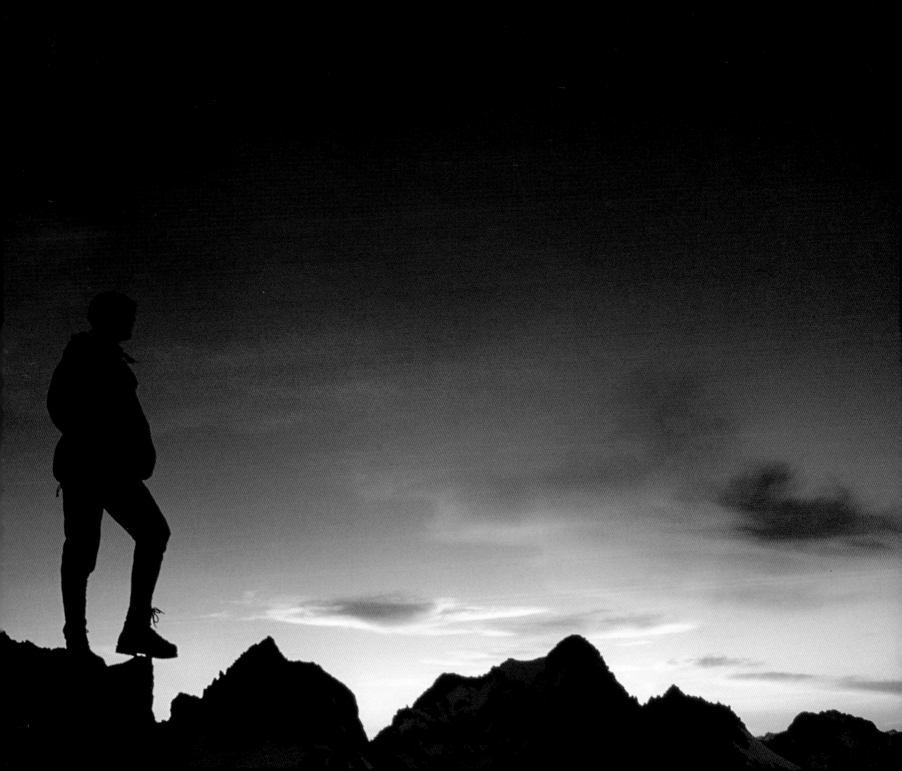

. . . I gulped when I turned around to look back and see all of

the state of California it would seem stretching out in three

directions under huge blue skies with frightening planetary

space clouds and immense vistas of distant valleys and even

plateaus and for all I knew whole Nevadas out there.

JACK KEROUAC

Spring atop the Palisades Range, Eastern Sierra

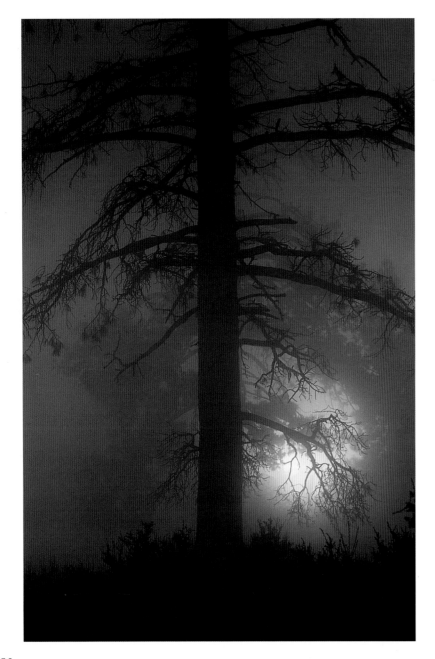

The Sierra forest is sunny-shady and dry for fully half the year. . . . The pine-needle floor is crunchy, the air is slightly resinous and aromatic, there is a delicate brushing of spiderwebs everywhere.

GARY SNYDER

Misty dawn through a Jeffrey pine,
Sherwin Plateau *(left)*, and lodgepole pines
near Second Lake, Palisade Range *(right)*

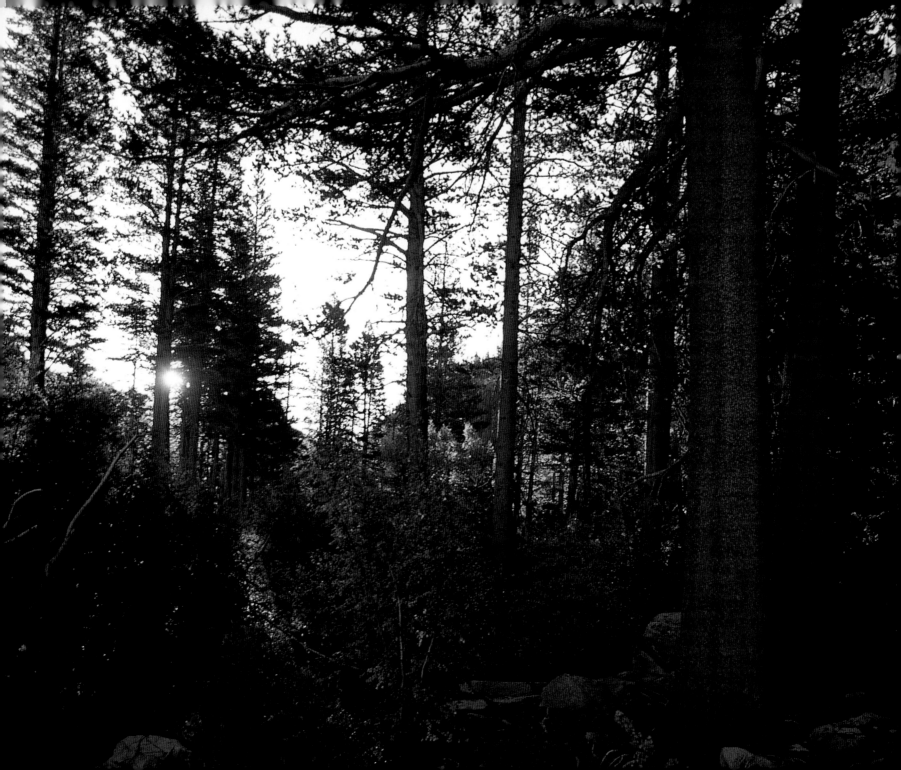

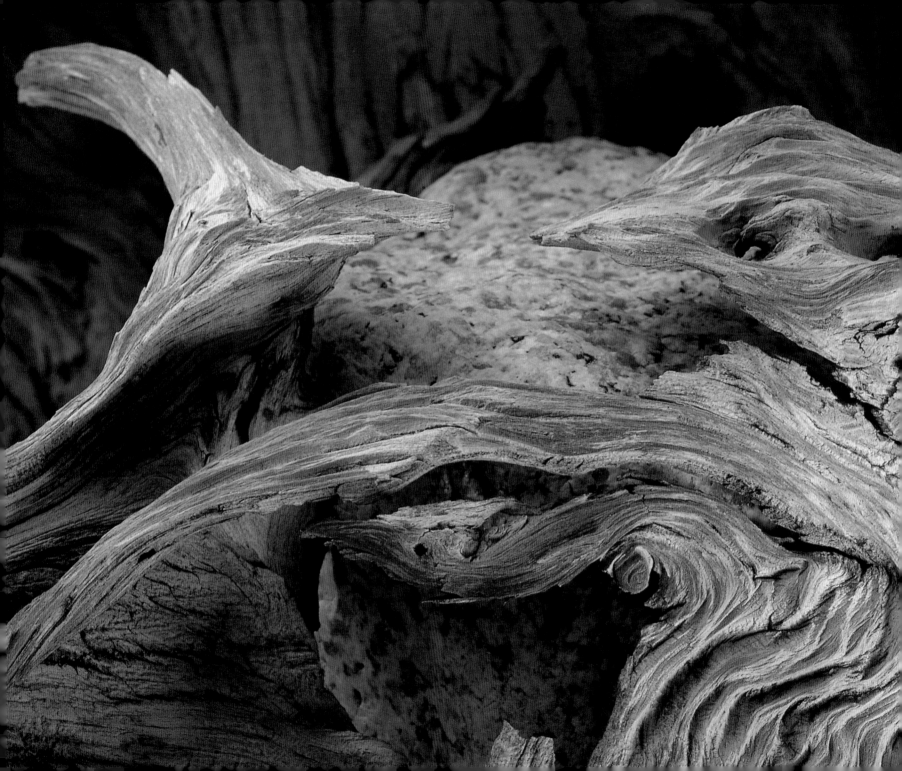

Within this tree

another tree

inhabits the same body;

with this stone

another stone rests,

its many shades of grey

the same,

its identical

surface and weight.

And within my body,

another body,

whose history, waiting,

sings: there is no other body,

it sings,

there is no other world.

JANE HIRSCHFIELD

Boulder trapped in whitebark pine roots,
Evolution Valley

Earth hath no sorrows

that earth cannot heal . . .

JOHN MUIR

Forest fire, Yosemite National Park

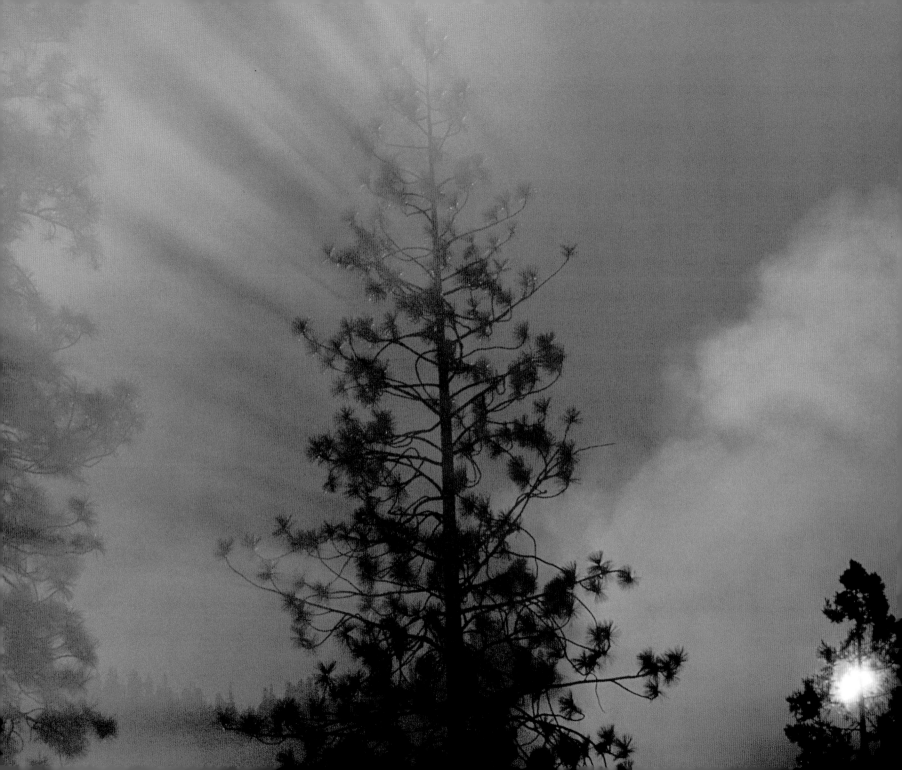

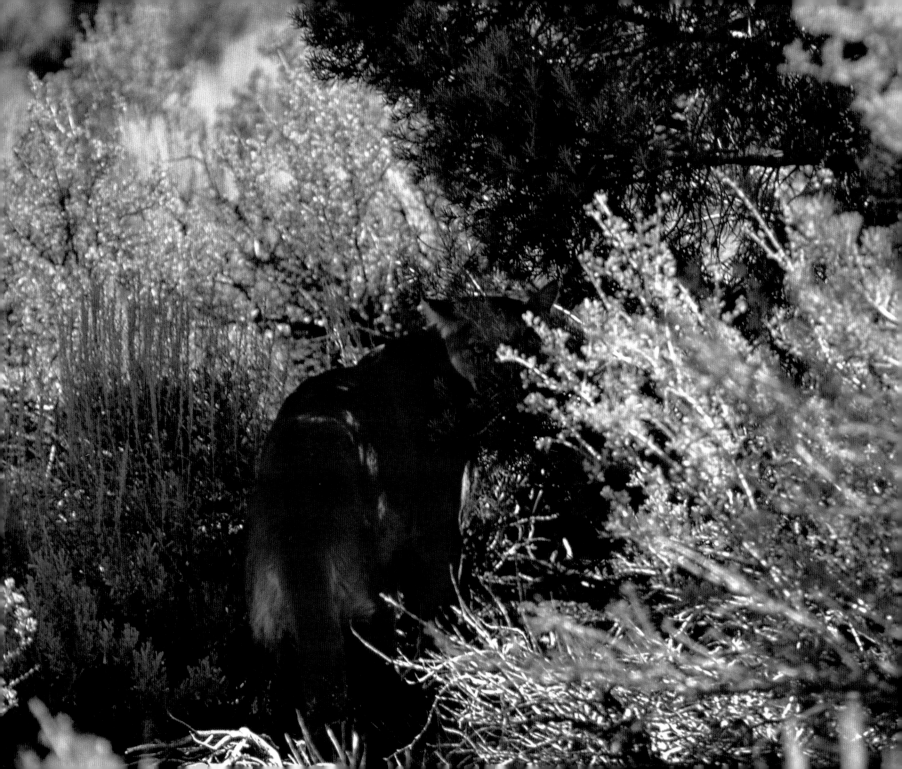

. . . how many hearts with warm red blood in them
are beating under cover of the woods, and how
many teeth and eyes are shining! A multitude of
animal people, intimately related to us, but of
whose lives we know almost nothing, are as busy
about their own affairs as we are about ours . . .

JOHN MUIR

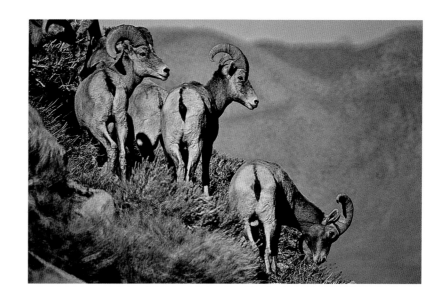

Wild mountain lion, Bishop Creek Canyon,
Eastern Sierra *(left)*, and endangered Sierra bighorn,
Sawmill Canyon *(right)*

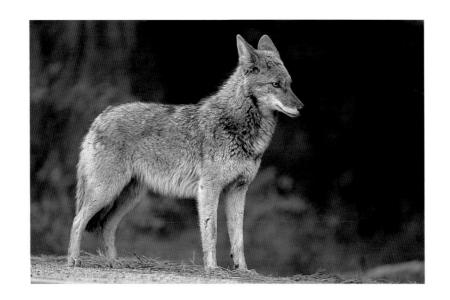

. . . In the high country that we love, trails are steep.
We climb each mile, breath by breath,
and at the threshold of pain, bliss overtakes us.

This life on earth, who can say what it is?
On Cold Mountain, Coyote crosses the summit snow
and leaves no trace.

MICHAEL HANNON

Coyote, Yosemite Valley *(left)*, and
10,000-foot escarpment of the Eastern
Sierra above Owens Valley *(right)*

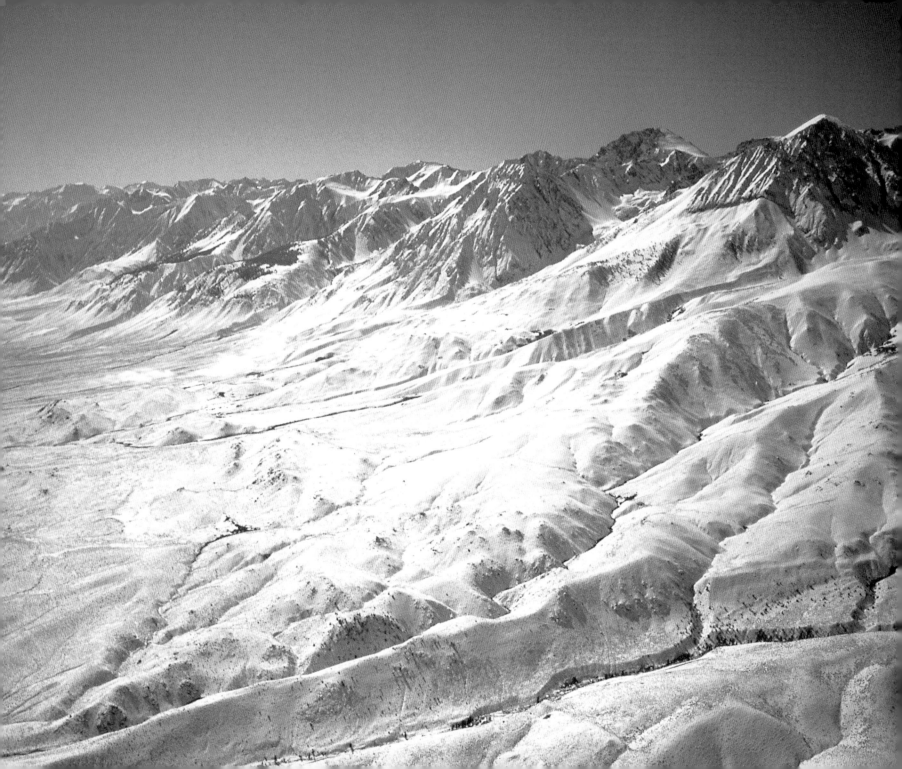

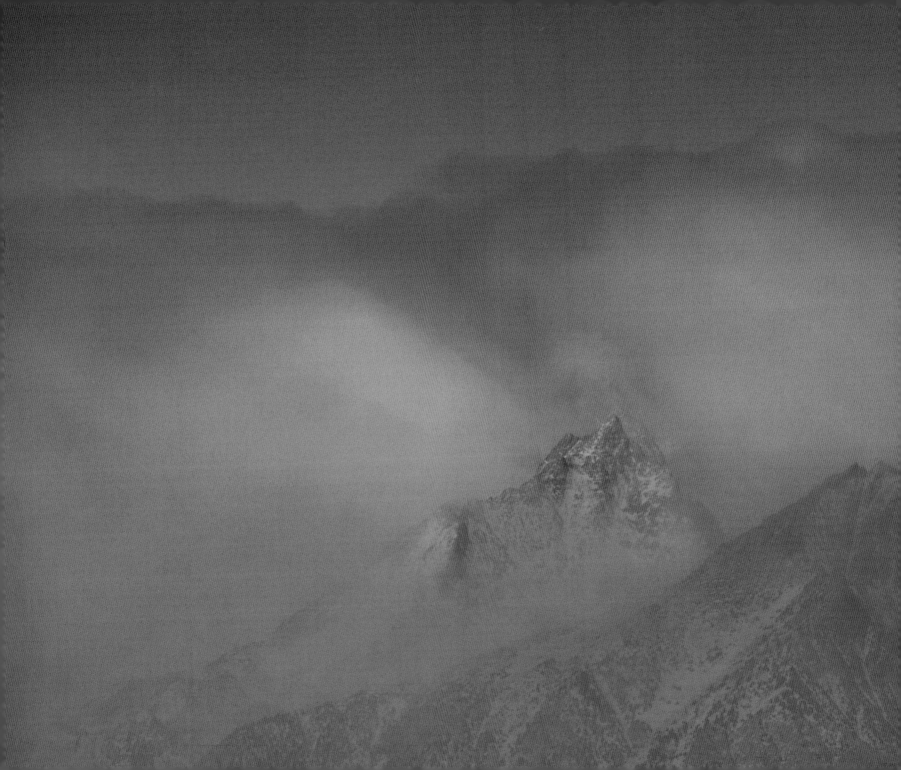

Nature is the true idealist. When she serves us best, when, on rare days, she speaks to the imagination, we feel that the huge heaven and earth are but a web drawn around us, that the light, skies, and mountains are but the painted vicissitudes of the soul.

RALPH WALDO EMERSON

Winter sunrise on Mount Humphreys, Eastern Sierra

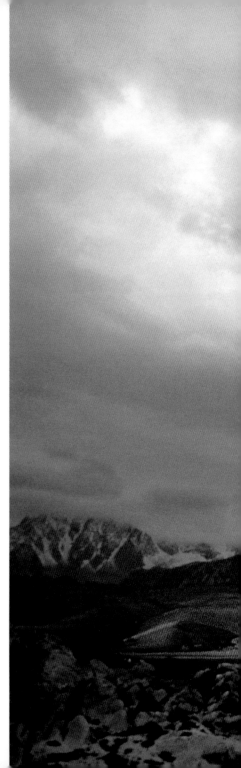

A storm that needed a mountain

met it where we were:

we woke up in a gale

that was reasoning with our tent,

and all the persuaded snow

streaked along, guessing the ground.

We turned from that curtain, down.

But sometime we will turn

back to the curtain and go

by plan through an unplanned storm,

disappearing into the cold,

meanings in search of a world.

WILLIAM STAFFORD

Stormy sunrise over Basin Mountain, Eastern Sierra

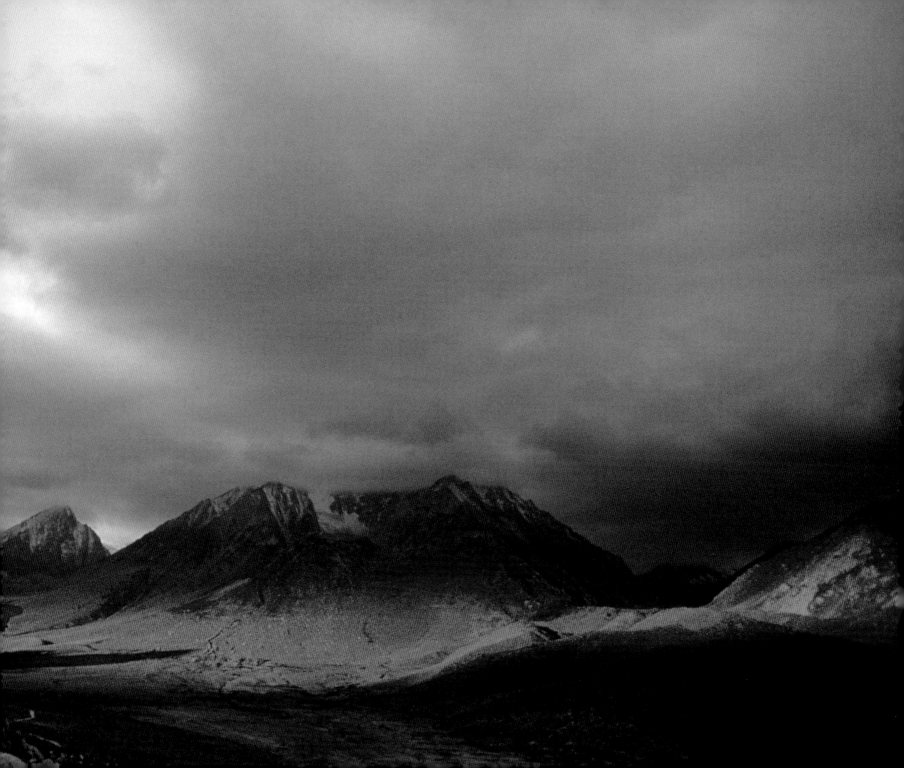

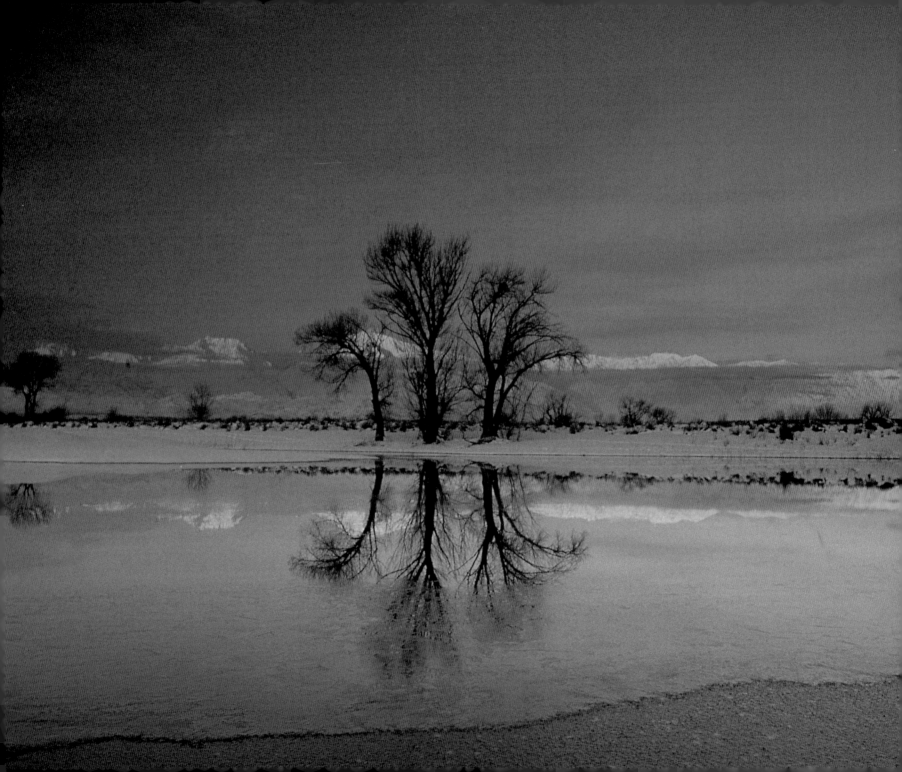

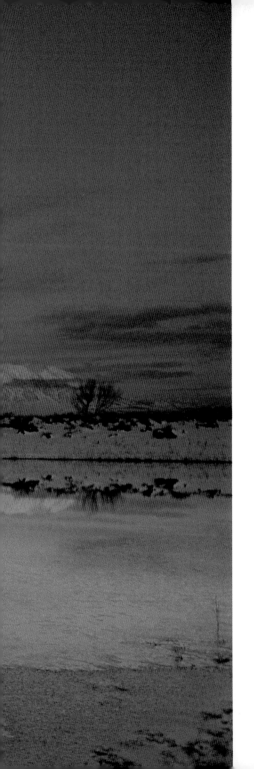

This day was solid overcast

Except for one thin band

On the eastern horizon,

Where it looked like the gallery

For Chinese landscapes was open for viewing.

The scroll was painted lengthwise,

A long stretch of snowfields

In the high Sierra pure white

In the new sun.

C. G. HANZLICEK

Winter sunrise on the Eastern Sierra over
an Owens Valley pond

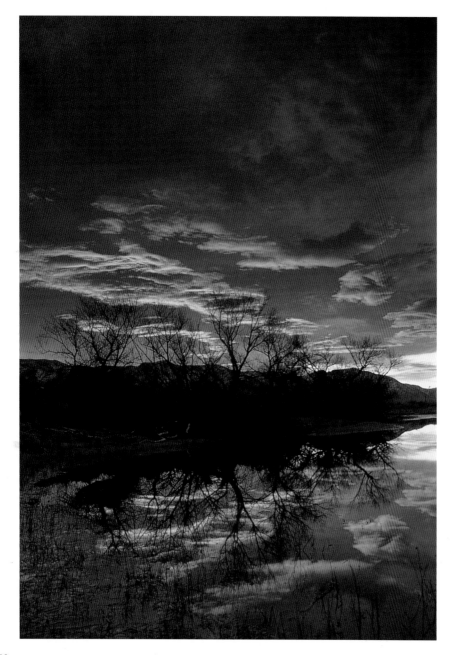

This grand show is eternal. It is always sunrise somewhere; the dew is never all dried at once; a shower is forever falling; vapor ever rising. Eternal sunrise, eternal sunset, eternal dawn and gloaming, on seas and continents and islands, each in its turn, as the round earth rolls.

JOHN MUIR

Winter sunrise over an Owens Valley pond near Laws (*left*), and sunset over the Owens River near Bishop, Eastern Sierra (*right*)

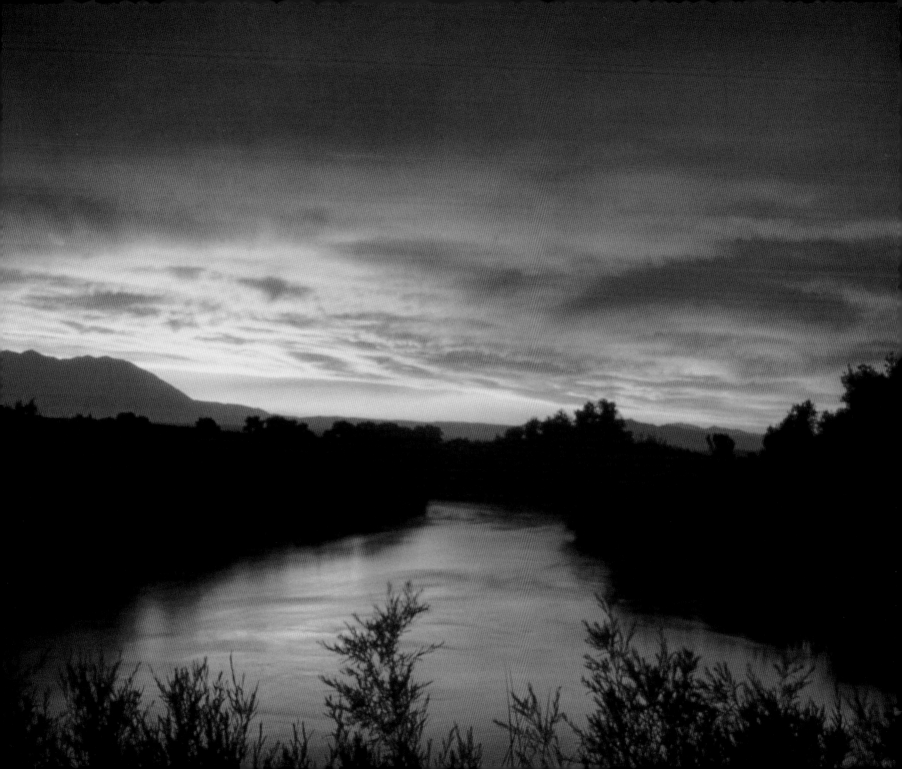

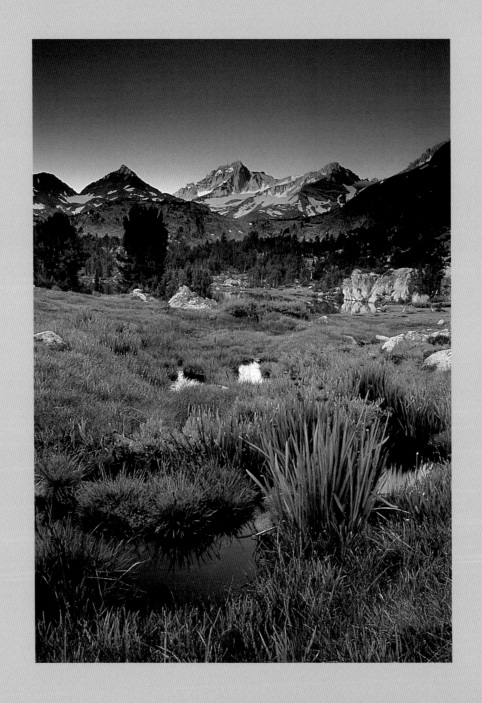

How lavish is Nature,

building, pulling down,

creating, destroying,

chasing every material particle

from form to form,

ever changing, ever beautiful.

JOHN MUIR

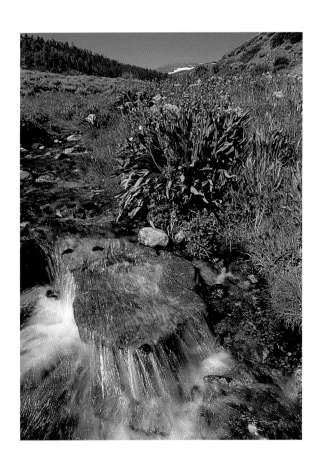

Wildflowers in the Eastern Sierra
beneath Bear Creek Spire *(left),* and
at 10,000 feet on Coyote Flat *(right)*

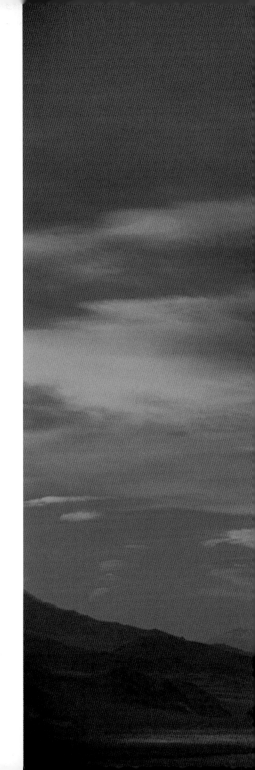

When the early morning light quietly

grows above the mountains . . .

The world's darkening never reaches

to the light of Being.

MARTIN HEIDEGGER

Sunrise on the Eastern Sierra from
the Owens Valley near Big Pine

76

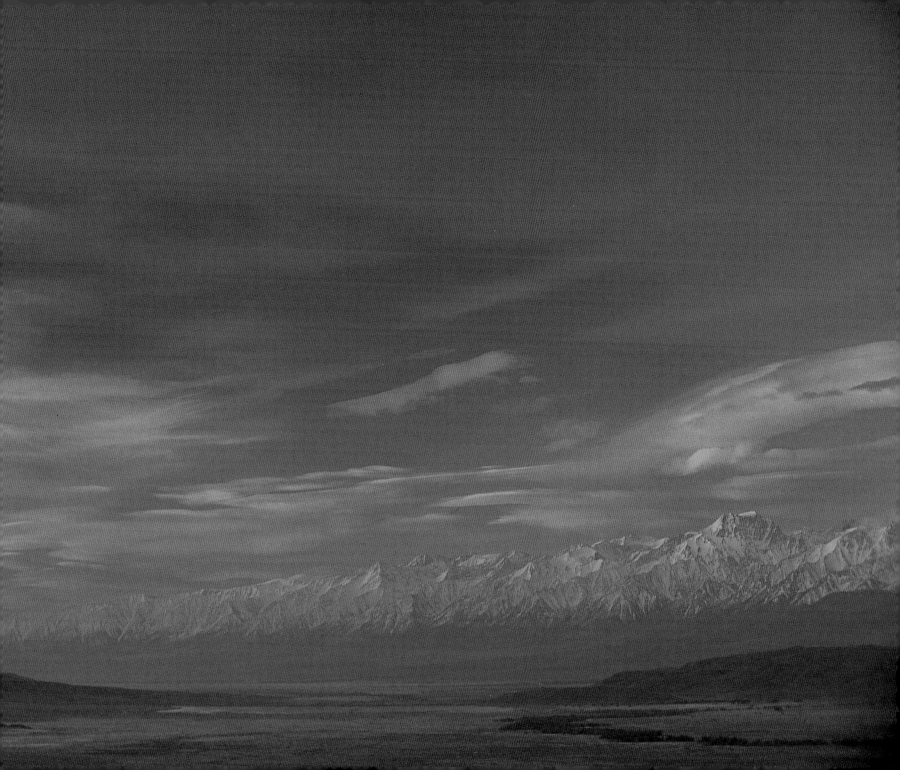

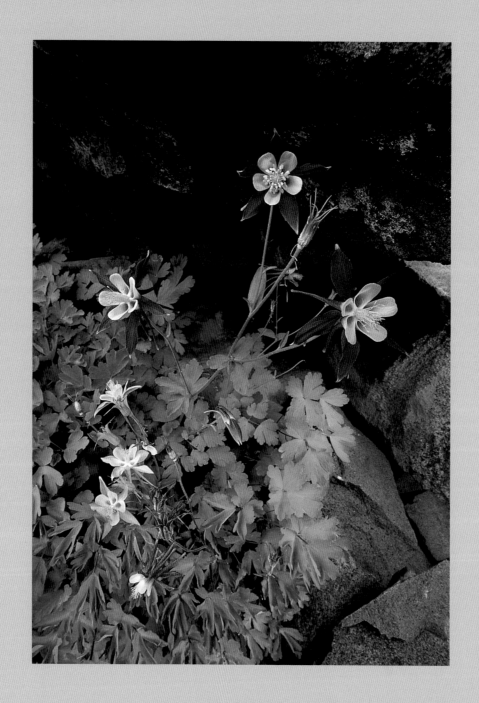

One impulse from a vernal wood

May teach you more of man,

Of moral evil and of good,

Than all the sages can.

WILLIAM WORDSWORTH

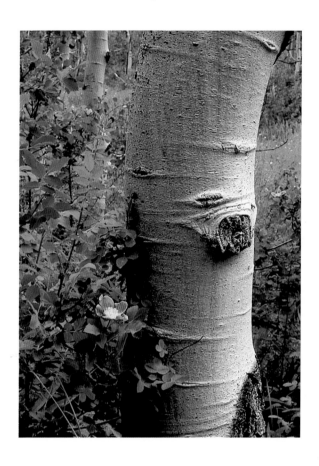

Columbine beneath Bear Creek Spire, Eastern
Sierra (*left*), and aspen and wild rose, Upper Rock
Creek Canyon, Eastern Sierra (*right*)

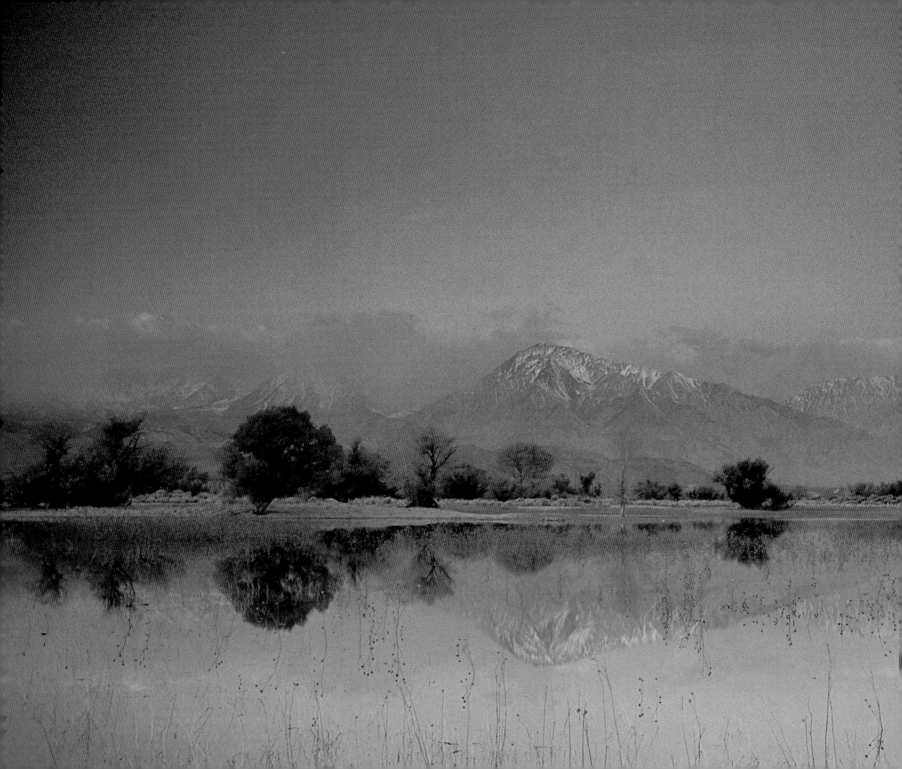

Nature does not cast pearls before swine.
There is just as much beauty visible to
us in the landscape as we are prepared
to appreciate.

HENRY DAVID THOREAU

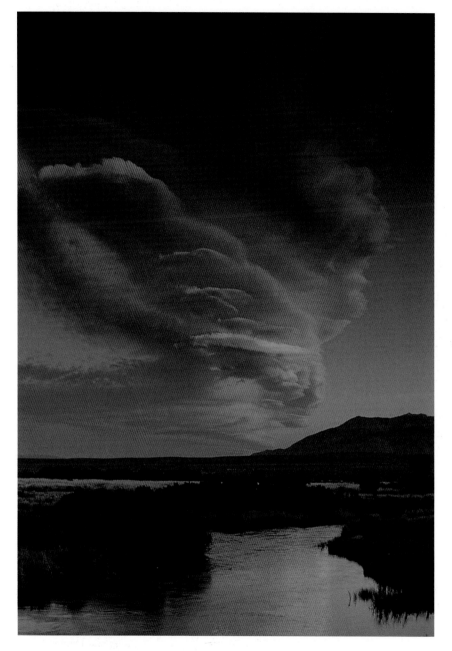

Twilight over Mount Tom from an Eastern Sierra pond (*left*),
and Sierra wave cloud and Owens River (*right*)

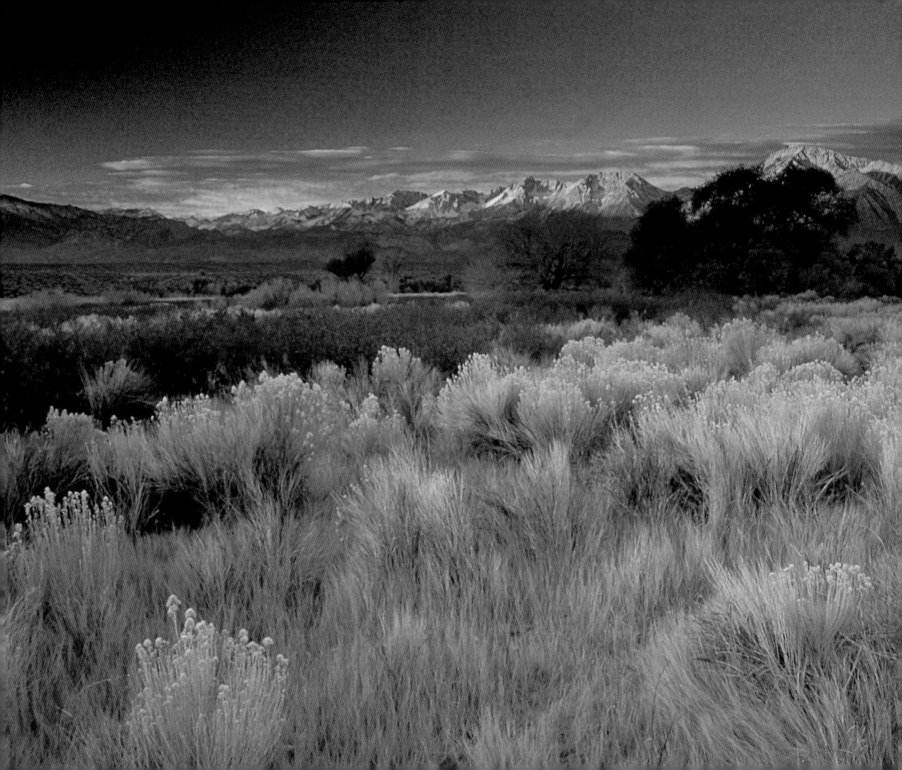

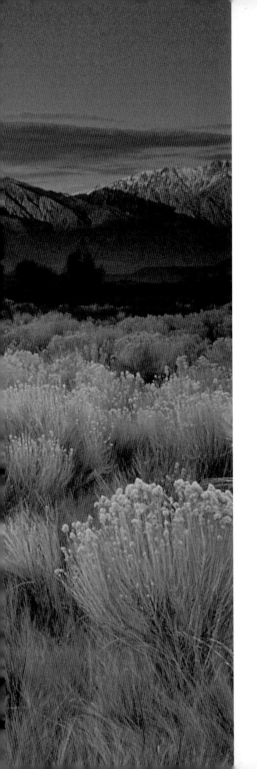

Yes, it is late summer in the West.

Even the grasses climbing the Sierras

reach for the next outcropping of rock

with tough, burned fingers. The thistle

sheds its royal robes and quivers

awake in the hot winds off the sun.

PHILIP LEVINE

Sage meadow at sunrise in
the Eastern Sierra near Bishop

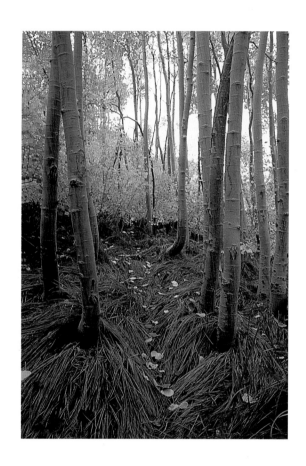

The little quaking aspen is one of the most lovable of all mountain trees. When unexpectedly found in meadows and garden spots of the High Sierra it is always an object of delight. The small delta-shaped leaves . . . are so fastened to their twigs that they tremble with the least breeze.

ANSEL HALL

Aspen grove, Kings Canyon (*left*), and full sunrise in
Bishop Creek Canyon, Eastern Sierra (*right*)

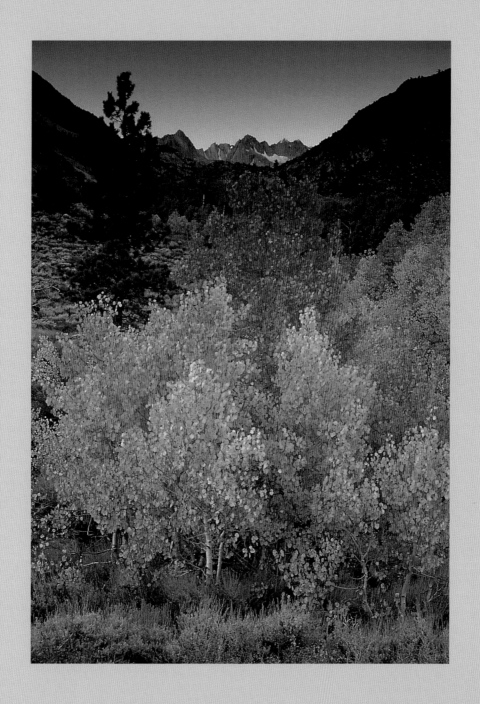

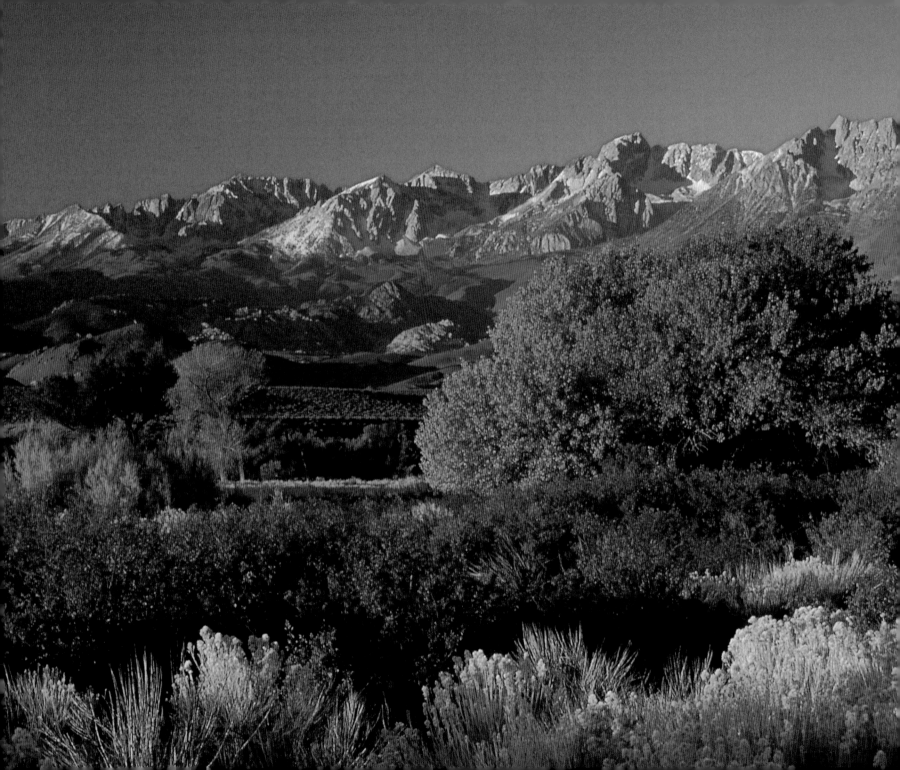

It is not like the play at the theatre, where everything is made conspicuous and aims to catch the eye, and where the story clearly and fully unfolds itself. On nature's stage many dramas are being played at once, and without any reference to the lookers-on, unless it be to escape their notice. The actors rush or strut across the stage, the curtain rises or falls, the significant thing happens, and we heed it not.

JOHN BURROUGHS

Fall colors in the Eastern Sierra near Bishop

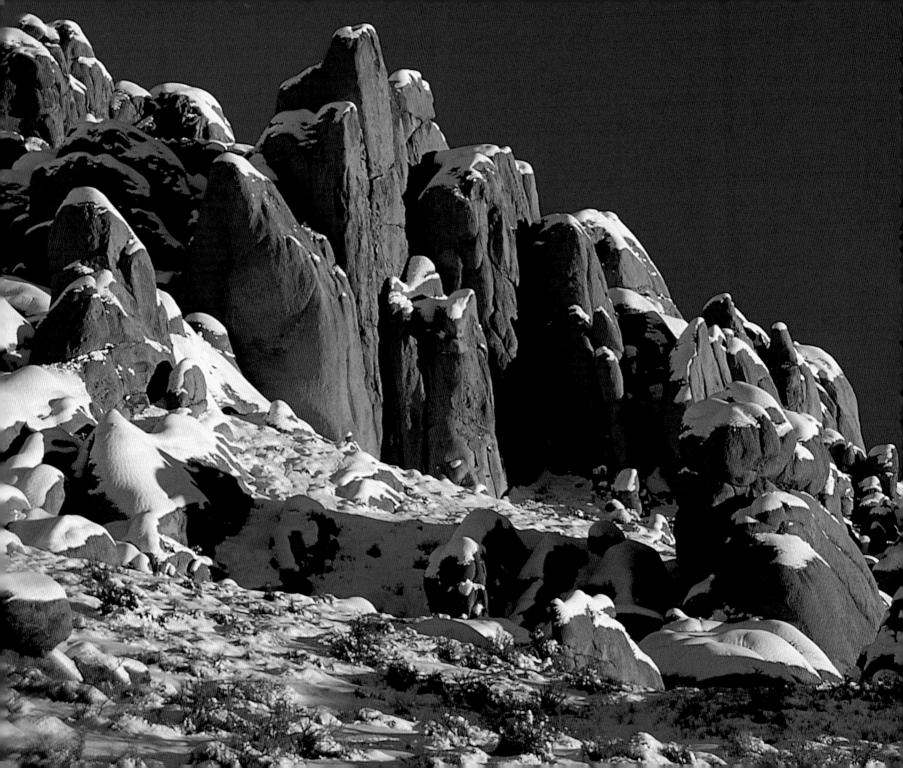

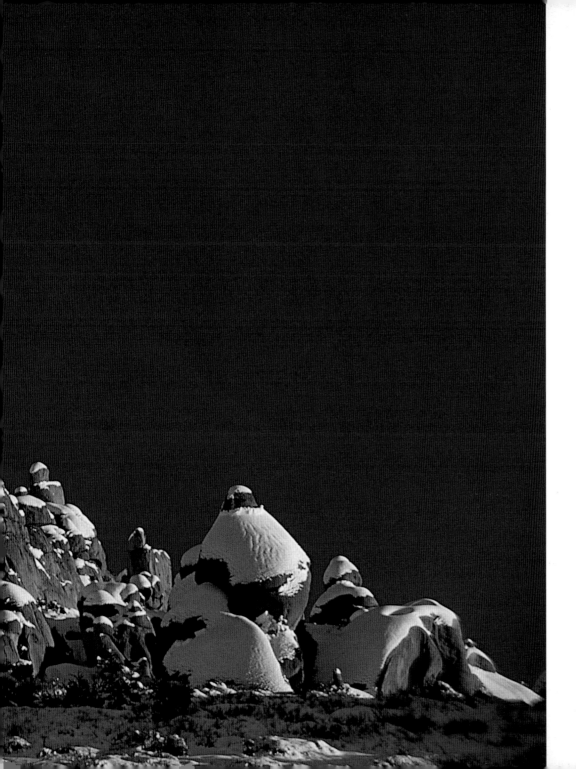

Winter sunrise on the Buttermilk Rocks,
Eastern Sierra

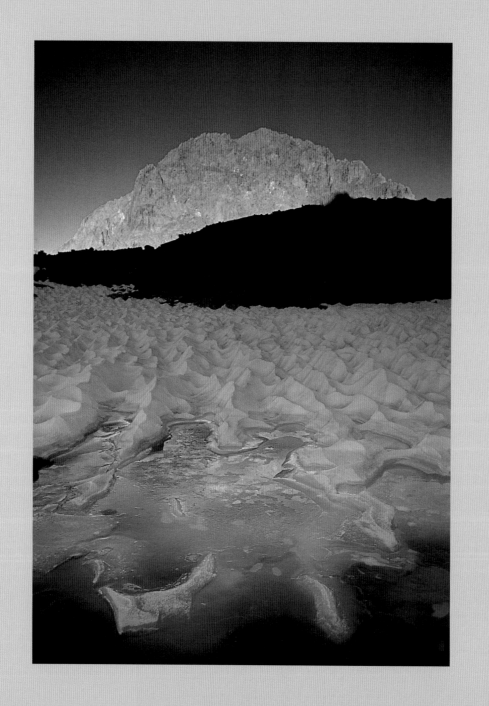

O my Mountain, my Mountain,

Enveloped in your cloak of snow,

Can you hear?

Temple of my night,

Cradle of my day,

Can you hear?

I warn you of the braggart of the sky,

The Sun! The Sun!

He outruns my warning words

To steal your snows,

O my Mountain, my Mountain.

Great body-guard of God—

Can you hear!

MAHDAH PAYSON

Late summer snow under Mount Williamson,
Eastern Sierra

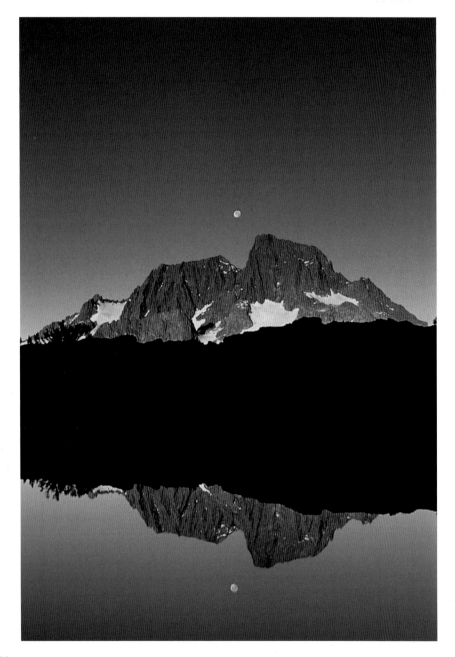

Reading these grand mountain manuscripts
displayed through every vicissitude
of heat and cold, calm and storm, upheaving
volcanoes and down-grinding glaciers,
we see that everything in Nature called
destruction must be creation—
a change from beauty to beauty.

JOHN MUIR

Moonset over Mount Ritter and Banner Peak (left), and
alpenglow on the east face of Mount Whitney (right)

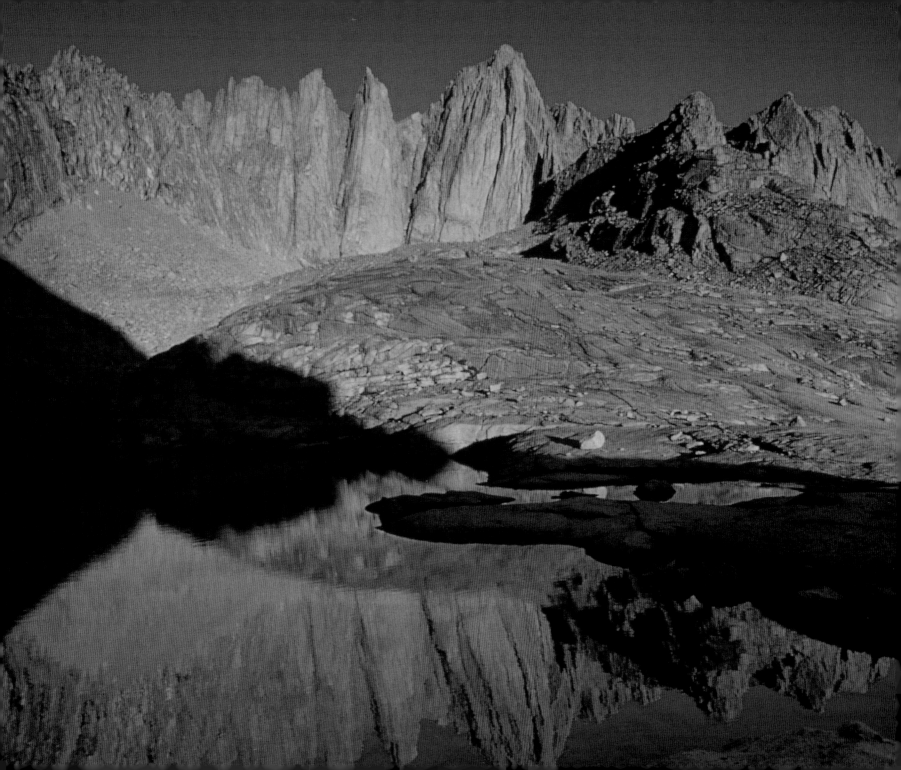

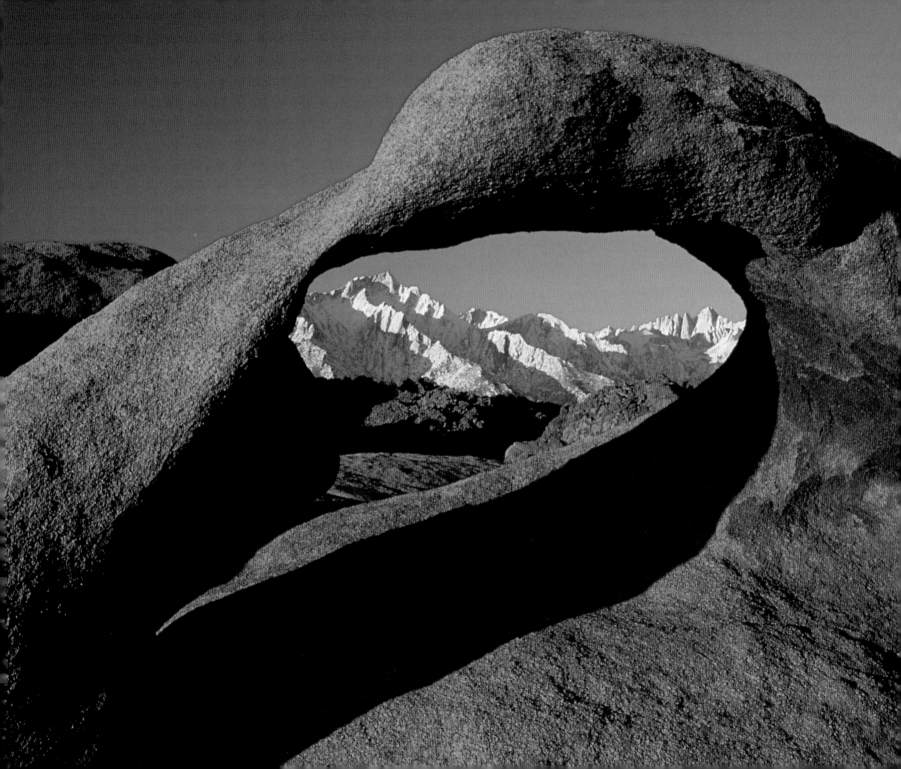

When we dwell with mountains, see them face to face, every day, they seem as creatures with a sort of life—friends subject to moods, now talking, now taciturn, with whom we converse as man to man. They wear many spiritual robes, at time an aureole, something like the glory of the old painters put around the heads of saints.

JOHN MUIR

Arch beneath Mount Whitney

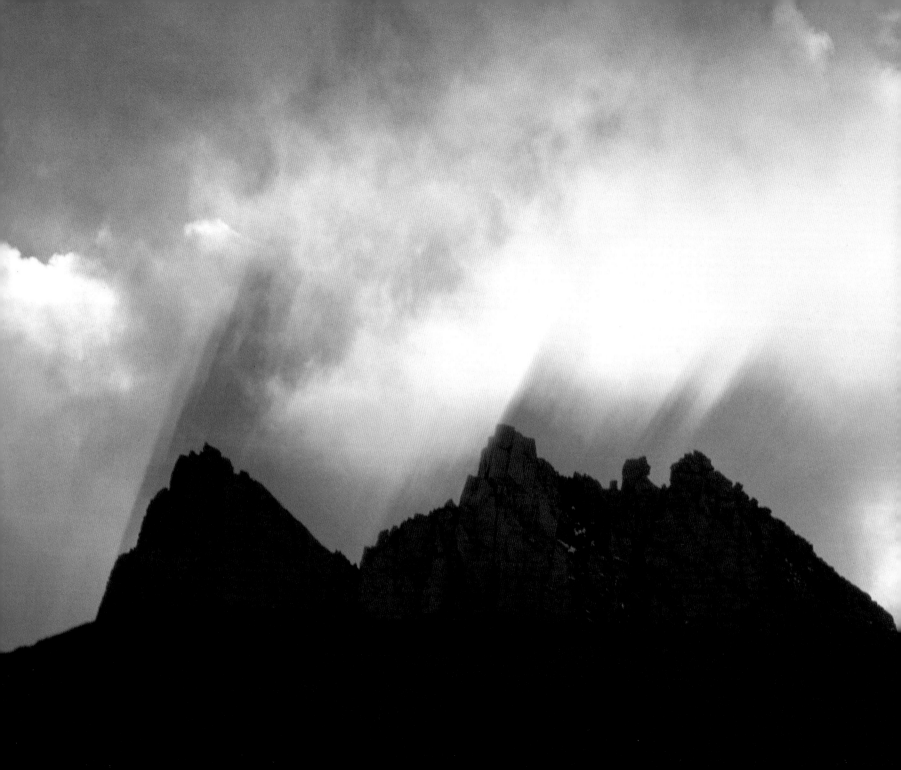

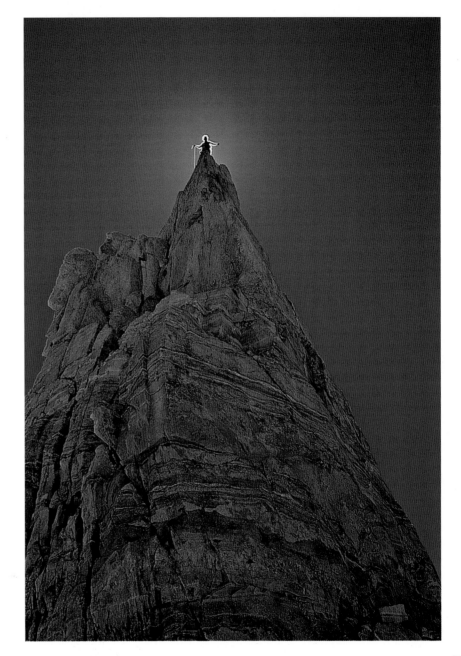

High over all the loftiest heads of all the valley herds,
The mountain spoke some most majestic words:

What said the venerable mountain to his brother,
Speaking as one great ancient poet to another?

"Last night I dreamed I knew—last night I dreamed I flew.
This morn I do not know!"

HARRY COWELL

Cloud shadows in the Mount Whitney region *(left),*
and climber on pinnacle near Mount Whitney *(right)*

The most beautiful experience we can have is the mysterious.

It is the fundamental emotion which stands at

the cradle of true art and true science.

ALBERT EINSTEIN

Castle Rock Spire, Sequoia National Park

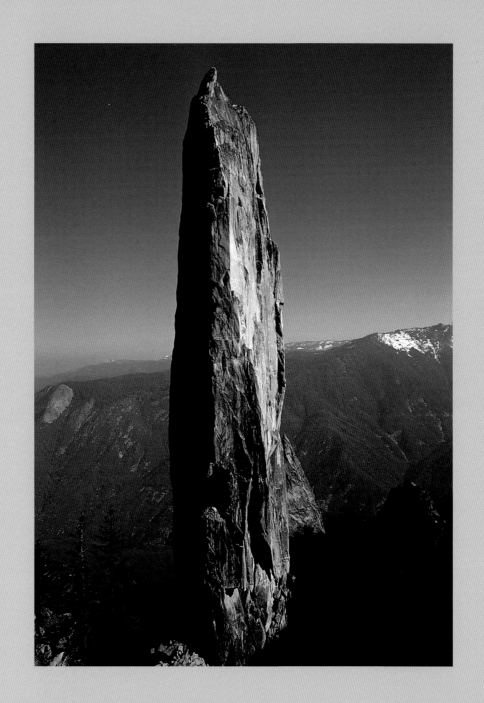

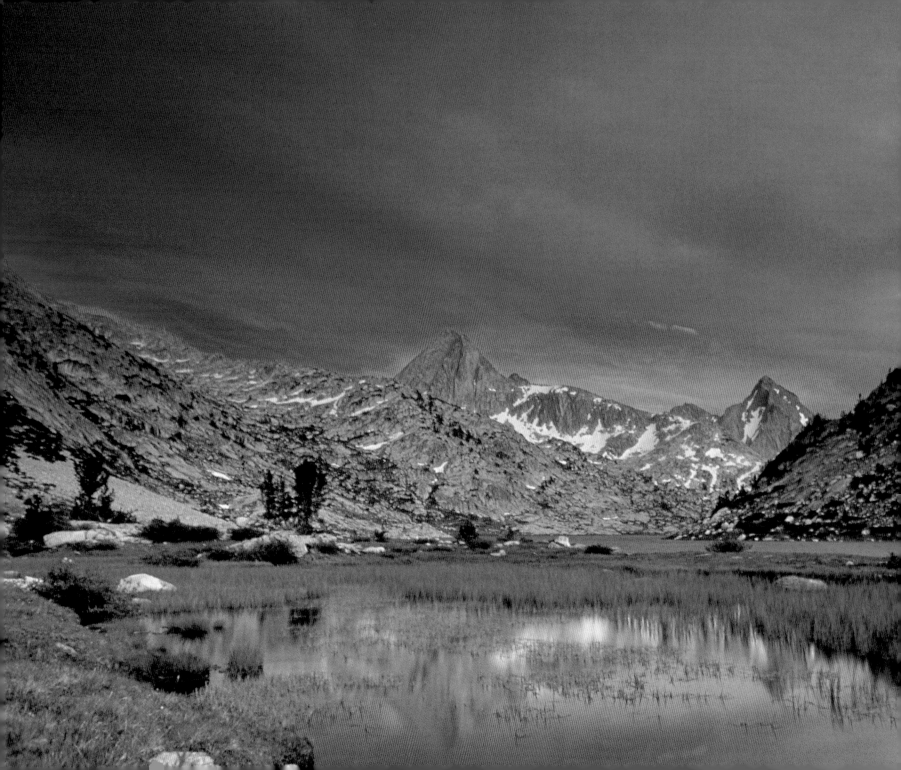

The sublime altitude of the mountains, their granite and barren heads piercing the sky . . . the more gentle and grassy slopes along the banks of the lake, the limpid and tranquil surface of which daguerreotypes distinctly every object, from the moss-covered rocks laved by its waves to the bald and inaccessible summits of the Sierra— these scenic objects . . . constituted a landscape that, from associations, melted the sensibilities, blunted as they were by long exposure and privation, and brought back to our memories the endearments of home and the pleasures of civilization.

EDWIN BRYANT

Stormy sunset on Evolution Lake, John Muir Trail,
Kings Canyon National Park

No Sierra landscape that I have seen holds anything

truly dead or dull . . . everything is perfectly clean

and pure and full of divine lessons.

JOHN MUIR

Wales Lake, Sequoia National Park

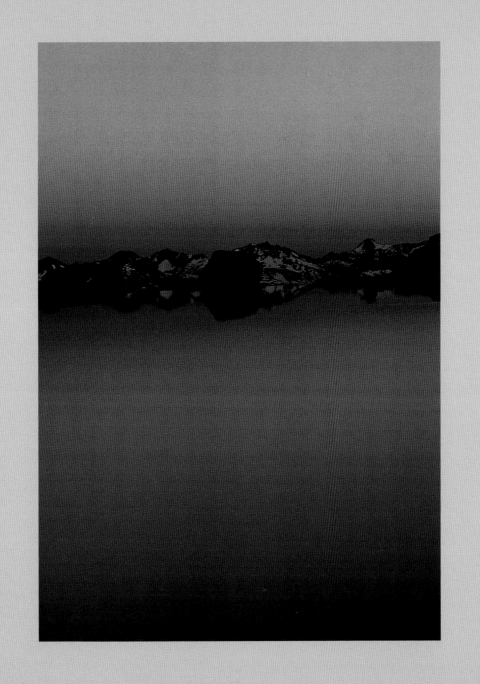

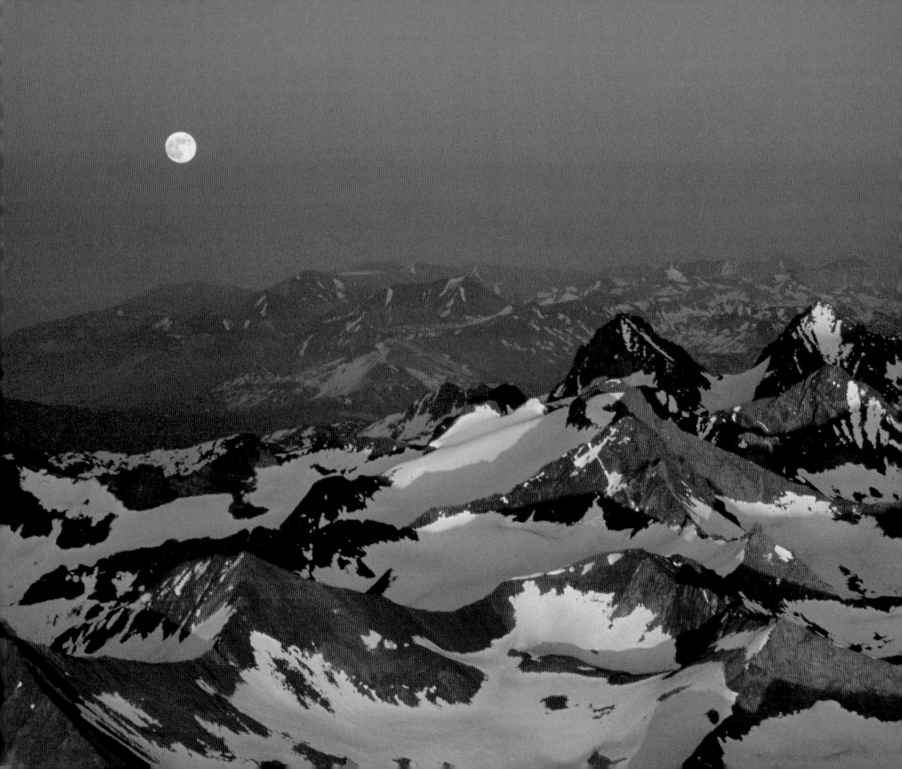

One granite ridge

A tree, would be enough

Or even a rock, a small creek,

A bark shred in a pool.

Hill beyond hill, folded and twisted

Tough trees crammed

In thin stone fractures

A huge moon on it all, is too much.

The mind wanders. A million

Summers, night air still and the rocks

Warm. Sky over endless mountains.

All the junk that goes with being human

Drops away, hard rock wavers

Even the heavy present seems to fail

This bubble of a heart.

Words and books

Like a small creek off a high ledge

Gone in the dry air.

A clear, attentive mind

Has no meaning but that

Which sees is truly seen.

No one loves rock, yet we are here.

Night chills. A flick

In the moonlight

Slips into Juniper shadow:

Back there unseen

Cold proud eyes

Of Cougar or Coyote

Watch me rise and go.

GARY SNYDER

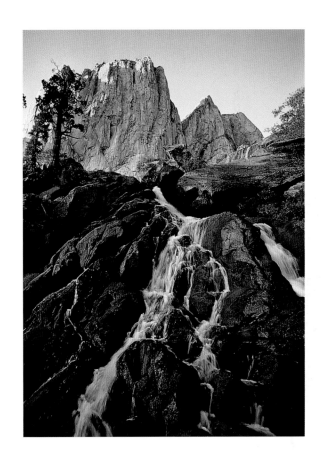

Aerial view at sunset of full moon rising over Mount Lyell
and Lyell Glacier (*left*), and Angel Wings and Hamilton Creek,
Sequoia National Park (*right*)

So many of us there are who have no majestic landscapes for

the heart—no grandeurs in the inner life. We live on the flats.

We live in a moral country, which is dry, droughty, barren.

We look up to no heights whence shadow falls and streams flow

singing. We have no great hopes. We have no sense of Infinite

guard and care. We have no sacred and cleansing fears.

We have no consciousness of Divine, All-enfolding Love.

We may make an outward visit to the Sierras, but there are

no Yosemites in the soul.

THOMAS STARR KING

Bridalveil Fall at Sunset, Yosemite Valley

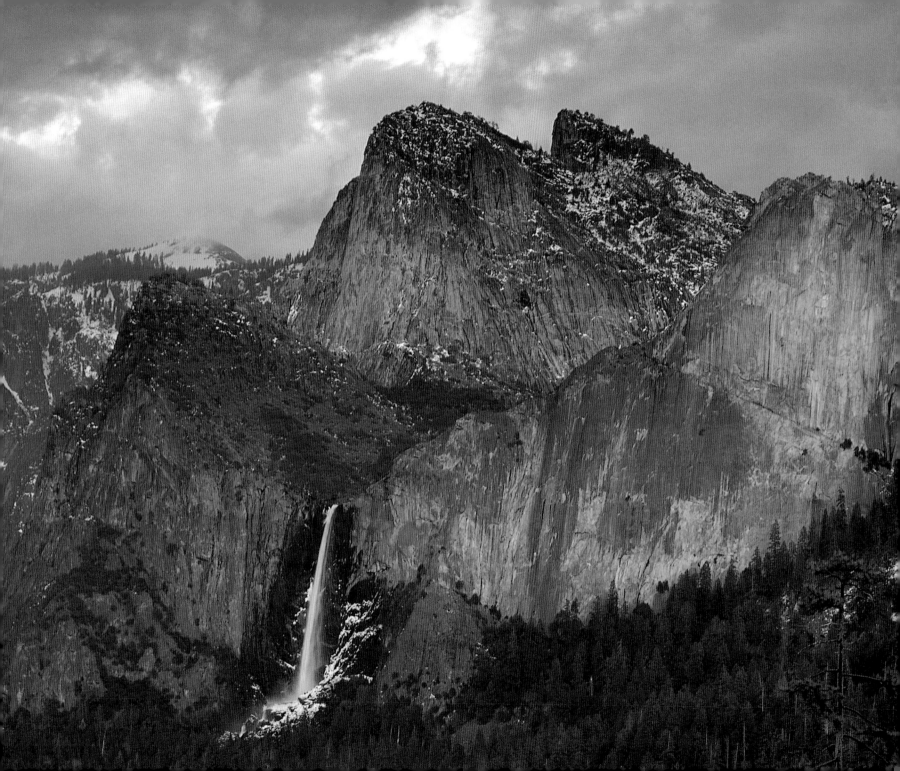

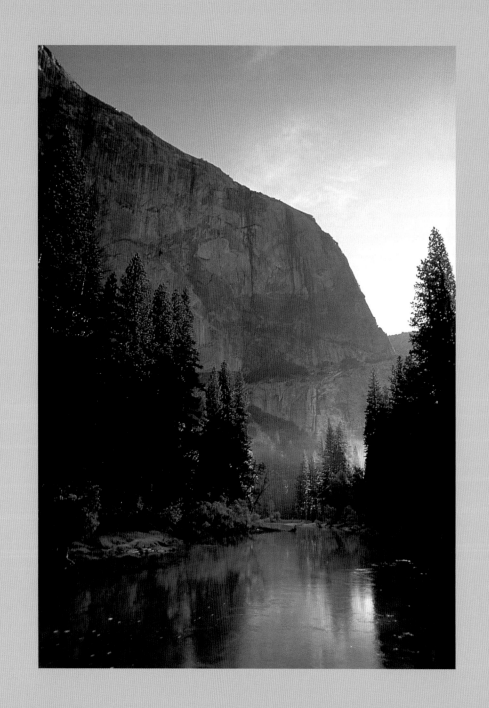

Grave and remote and austere,

you haunt me with beauty, oh valley,—

Beauty undreamed of before,

now all a dream or a star.

CHARLES WHARTON STORK

Dawn over the Merced River below El Capitan,
Yosemite Valley

BIBLIOGRAPHY

Bryant, Edwin. *What I Saw in California*. Lincoln: University of Nebraska Press, 1985.

Burroughs, John. "Hasty Observation." *Riverby*. Boston and New York: Houghton Mifflin and Company, 1894.

Cowell, Harry, et al. *Songs and Stories,* selected by Edwin Markham. San Francisco: Powell Publishing Company, 1933.

Einstein, Albert. "The World As I See It." *Forum and Century,* Vol. 84, New York: Forum Publishing Company, 1930.

Emerson, Ralph Waldo. "Nature and Imagination." *The Complete Works of Ralph Waldo Emerson*. Boston: Houghton Mifflin and Company, 1903.

Farquhar, Francis P. *History of the Sierra Nevada*. Berkeley and Los Angeles: University of California Press in collaboration with The Sierra Club, 1965.

Hall, Ansel (editor). *Handbook of Yosemite National Park: A Compendium of Articles on the Yosemite Region by the Leading Scientific Authorities*. New York and London: G. P. Putnam's Sons, 1921.

Hannon, Michael, et al. *The Geography of Home: California Poetry of Place*. Berkeley: Heyday Books, 1999.

Hanzlicek, C. G. *The Cave: Selected and New Poems*. Pittsburgh: University of Pittsburgh Press, 2001.

Heidegger, Martin. *Poetry, Language, and Thought*. Translated by Albert Hofstadter. New York: HarperCollins Publishers, 1975.

Hirschfield, Jane. *The October Palace*. New York: HarperCollins Publishers, 1994.

Kerouac, Jack. *The Dharma Bums*. New York: Buccaneer Books, 1995.

King, Thomas Starr. *The White Hills, Their Legends, Landscape and Poetry*. Boston: William F. Gill & Company, 1886.

Kneeland, Samuel. *The Wonders of Yosemite and of California*. Boston: Alexander Moore, Lee and Shepard, 1872.

LeConte, Joseph. *A Journal of Ramblings Through the High Sierra of California by the University Excursion Party*. San Francisco: Sierra Club Books, 1930.

Levine, Philip. *A Walk with Tom Jefferson*. New York: Alfred A. Knopf, 1988.

McGrath, Thomas. *Selected Poems 1938–1988*. Port Townsend, Washington: Copper Canyon Press, 1988.

Merwin, W. S. *The Rain in the Trees*. New York: Alfred A. Knopf, a division of Random House, Inc., 1988.

Muir, John. *John of the Mountains: The Unpublished Journals of John Muir*. Boston: Houghton Mifflin and Company, 1938.

Muir, John. *My First Summer in the Sierra*. San Francisco: Sierra Club Books, 1990.

Muir, John. *Our National Parks*. Boston and New York: Houghton Mifflin and Company, 1909.

Muir, John. "Explorations in the Great Tuolumne Cañon." *Overland Monthly*. San Francisco: A. Roman & Company, 1873.

Payson, Mahdah, et al. *Golden Songs of the Golden State,* selected by Marguerite Wilkinson. Chicago: A. C. McClurg & Company, 1917.

Rowell, Galen. *Mountain Light*. San Francisco: Sierra Club Books, 1986.

Salazar, Dixie, et al. *The Geography of Home: California Poetry of Place*. Berkeley: Heyday Books, 1999.

Snyder, Gary. *The Practice of the Wild: Essays*. San Francisco: North Point Press, 1990.

Snyder, Gary. *Riprap and Cold Mountain Poems*. San Francisco: North Point Press, 1990.

Stafford, William. *The Darkness Around Us is Deep*. New York: HarperPerennial, 1993. Reprinted by permission of the estate of William Stafford.

Stegner, Wallace, et al. *Many Californias: Literature from the Golden State,* edited by Gerald Haslam. Reno: University of Nevada Press, 1999.

Stegner, Wallace. *The Sound of Mountain Water*. Garden City, New York: Doubleday, 1969.

Stork, Charles Wharton, et al. *Golden Songs of the Golden State,* selected by Marguerite Wilkinson. Chicago: A. C. McClurg & Company, 1917.

Thoreau, Henry David. "Autumnal Tints." *The Atlantic Monthly;* Oct. 1862; Vol. X, No. LX. Berkeley: University of California Press, 1993.

Twain, Mark. *Roughing It*. Berkeley: UC Press, 1993.

Whittier, John Greenleaf. *The Poetical Works of John Greenleaf Whittier*. Boston: Ticknor and Fields, 1867.

Wordsworth, William. *Selected Poems*. New York: Penguin Books, 1994.

Zwinger, Ann. *Yosemite: The Valley of Thunder*. San Francisco: HarperCollins Publishers, 1996.

Concept and design by Jennifer Barry Design, Fairfax, CA.
Layout production by Kristen Wurz.
Editorial research assistance by David Booth, San Francisco, CA.

Published by Sasquatch Books
Printed in China
Distributed by Publishers Group West
09 08 07 06 05 04 03 6 5 4 3 2 1

Library of Congress Cataloging in Publication Data

Rowell, Galen A.
Yosemite & the wild Sierra / photographs and foreword by Galen Rowell;
edited by Jennifer Barry.
p. cm.
Includes bibliographical references.
ISBN 1-57061-347-8
1. Yosemite National Park (Calif.)–Pictorial works. 2. Yosemite National Park (Calif.)–Quotations, maxims, etc.
3. Sierra Nevada (Calif. and Nev.)–Pictorial works. 4. Sierra Nevada (Calif. and Nev.)–Quotations, maxims, etc.
I. Title: Yosemite and the wild Sierra. II. Barry, Jennifer. III. Title.

F868.Y6R65 2003
917.94'470022'2--dc21

2002044647

Sasquatch Books / 119 S. Main Street, Suite 400 / Seattle, Washington 98104
206/467-4300 / www.sasquatchbooks.com / books@sasquatchbooks.com

Photo captions: cover, Bridalveil Fall at Sunset, Yosemite Valley, California;
p. 2, Twilight over Half Dome from Olmsted Point;
pp. 4–5, Dawn from Mount Mendel, Evolution Peaks, Kings Canyon National Park.